POSTCARD HISTORY SERIES

Grinnell

IN VINTAGE POSTCARDS

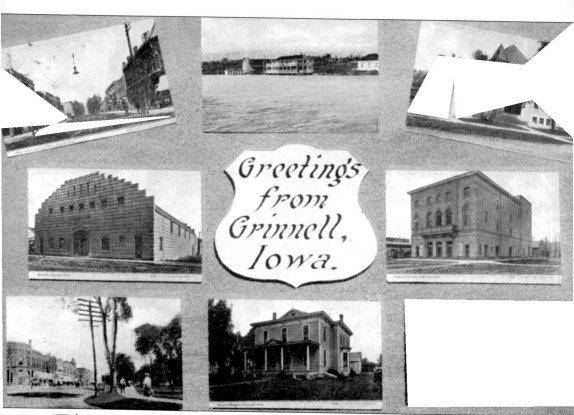

"Welcome to Grinnell, Iowa," proclaims this commercially-produced postcard which dates to *c*. 1907. It features popular postcards of the era, including images of Arbor Lake, the Colonial Theater, Main Street, Broad Street, and Stewart Library. (Ivan Sheets Collection.)

POSTCARD HISTORY SERIES

Grinnell

IN VINTAGE POSTCARDS

Bill Menner

ARCADIA

Published by Arcadia Publishing,
an imprint of Tempus Publishing, Inc.
Charleston SC, Chicago, Portsmouth NH,
San Francisco

Printed in Great Britain.

Library of Congress Catalog Card Number: 2003114305

For all general information contact Arcadia Publishing at:
Telephone 843-853-2070
Fax 843-853-0044
E-Mail sales@arcadiapublishing.com
For customer service and orders:
Toll-Free 1-888-313-2665

Visit us on the internet at http://www.arcadiapublishing.com

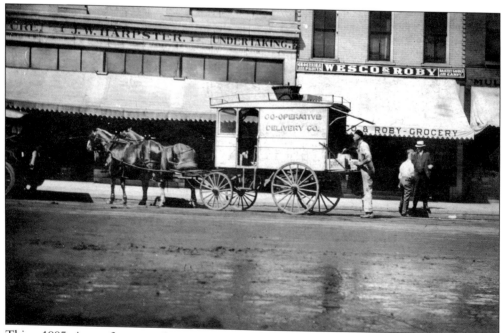

This *c.* 1905 picture features a driver with horse and wagon. It was taken in front of the building at 903 Main Street, now the Odd Fellows Hall. (Grinnell College Archives.)

CONTENTS

ACKNOWLEDGMENTS

Many people contributed to the creation of this book. Ivan Sheets was an early contributor and adviser, sharing his vast collection of postcards and remarkable knowledge of local history. Dorrie Lalonde, who oversees the archives at Grinnell's Stewart Library, provided important insight and advice. Catherine Rod and Cheryl Neubert at Grinnell College's Burling Library also shared their knowledge and experience, as well as access to the wonderful cards in the college's collection.

Mike Hotchkin, Marian Dunham, and Mickey Munley generously allowed me to pore over their collections and make use of the mint-condition cards included within. Rick Storbeck was a constant source of information and insight. Byron Worley, Karen Groves, Wally Walker, Dorothy Pinder, Mary Schuchmann, and Bob Smith were kind to review the text.

My co-worker at Grinnell Renaissance, Robin Young, was an enthusiastic contributor of ideas, insights, and local history. Her concurrent work on behalf of Grinnell's sesquicentennial was a source of additional information.

I have absorbed information from many sources during my research. Students of Grinnell history will want to read J.B. Grinnell's autobiography, Charles E. Payne's biography of Grinnell, Alan Jones' history of the college, *Pioneering*, Bill Deminoff's *Campus and Community: A Tour Guide to Grinnell College and Grinnell, Iowa,* Dorothy Pinder's wonderful *In Old Grinnell* and *Grinnell: Then and Now*, and Wally Walker's unpublished paper on Grinnell College buildings.

In conclusion, my family was kind not to snicker when I would ramble on about the latest postcard or historical tidbit I had discovered. Jack, Robbie, Ann, and Kate were supportive, despite their dad's occasional preoccupation. My wife, Barb, was patient and understanding. They have my love and my thanks. This book is dedicated to them.

INTRODUCTION

Grinnell, Iowa, isn't your typical small town on the prairie. That's as much the case today as it was in 1854, when the Reverend J.B. Grinnell arrived with a zealous band of New England Congregationalists determined to establish an abolitionist community with a commitment to education.

When they arrived, they found a treeless prairie with great promise. Grinnell had inside information that the Mississippi and Missouri Railroad would be extended, and that a train depot would be located near the site. That, and the fact that Iowa was a free state that did not permit slavery, was enough to convince the group they had found a location for their Congregationalist utopia.

Grinnell is a community that has thrived on activism, vision and persistence. It welcomed John Brown on his final journey that ultimately led him to Harper's Ferry. It survived a series of disasters, including an 1882 tornado that devastated the community and killed 40 people. It invited architect Louis Sullivan, during the final decade of his life, to create a masterpiece (one of his jewel-box banks, the Merchants National Bank building). And it helped nurture a small college into one of the finest liberal arts institutions in the country.

Grinnell College has, in many ways, helped drive the growth of the community. But the town-gown relationship has been mutually advantageous. When he first planned the community, J.B. Grinnell included 170 acres for a university. He founded Grinnell University in 1857, and two years later lured Iowa College from Davenport to merge with his small school. The presence of a college—even a small "Western" college—attracted students and faculty who might not otherwise reside in, or even visit, a small prairie town.

The city, however, contributed its share to the college's success. For example, local boys Harry Hopkins and Robert Noyce chose to stay in Grinnell for their undergraduate studies. Hopkins wound up shaping the New Deal while serving as President Franklin Roosevelt's closest adviser. Noyce invented the integrated circuit and co-founded Intel Corporation.

Transportation also played a vital role in Grinnell's development. From the railroad that first attracted J.B. Grinnell to the Pony Express route and Mormon handcart trail that passed nearby, Grinnell has been a hub of transportation innovation.

H.W. Spaulding founded a buggy manufacturing firm in Grinnell in 1876, and eventually branched into the automobile business. A preview of things to come occurred in 1913, when a Spaulding auto defeated the Rock Island Railroad's fast mail train in a race along the River-to-River Road (Highway 6) from Davenport to Council Bluffs.

Grinnellian Billy Robinson set a record of his own in 1914, that for non-stop flight. He flew an airplane (with the radial engine he developed) 370 miles from Des Moines to Kentland,

Indiana. Robinson died in a plane crash two years later, but his pioneering achievements were integral to the aviation industry.

Transportation, via the "automobile age," impacted Grinnell in another way. As privately-owned vehicles became more common, the need for roads increased. And Grinnell sat squarely on Highway 6, one of the primary east-west thoroughfares.

Hence, it became a destination. Travelers passed through Grinnell on Highway 6. As they matriculated, college students developed four-year relationships with the community. Residents of nearby farm communities and rural farmsteads saw Grinnell as their closest source of goods, social interaction, and entertainment. The town grew, and as this book indicates, so too did the many positive depictions of Grinnell in both commercial and real-photograph postcards.

These historic impressions of Grinnell fascinate modern-day residents. Many of the landmarks featured in these sometimes century-old postcards remain landmarks today. The structural core of downtown Grinnell has changed little in the last 100 years. Yet the missing pieces prominent in many postcards—the old Congregational church, the Iowa Theatre, and Blair, Chicago, and Alumni Halls on campus—prompt more questions than answers.

Grinnell remains a destination today. It sits four miles from a major thoroughfare (Interstate 80), the college lures students from all 50 states and 50 foreign countries, and its wonderfully-preserved buildings attract architects and architecture devotees alike.

The postcards in this book give us a glimpse of another time. They show the people and the places that helped shape the community, and provide a visual link to the past.

One
GO WEST!

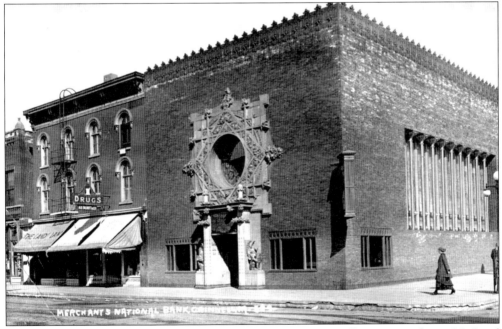

Here are two of Grinnell's most famous landmarks: Louis Sullivan's Merchants National Bank building and The Candyland (with awning, far left). The candy store and soda fountain built a reputation that lives on in Grinnell today. (Mike Hotchkin Collection.)

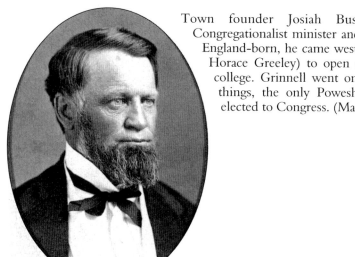

Town founder Josiah Bushnell Grinnell was a Congregationalist minister and fervent abolitionist. New England-born, he came west (at the reported urging of Horace Greeley) to open a church and eventually a college. Grinnell went on to become, among other things, the only Poweshiek County resident ever elected to Congress. (Marian Dunham Collection.)

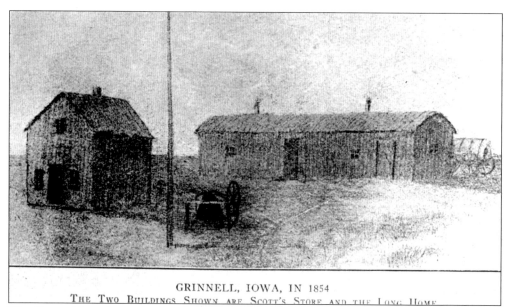

GRINNELL, IOWA, IN 1854
The Two Buildings Shown are Scott's Store and the Long Home

The "Long Home" was the first building in Grinnell, erected in June of 1854, just months after J.B. Grinnell founded the town. The Long Home was intended to accommodate travelers and provide temporary shelter for new settlers. Shortly thereafter, the Long Home became Scott's Store, built by Anor Scott. It was so small that Scott had to crawl through a hole that doubled as a door in order to get the goods and hand them out to customers. (Stewart Library Collection.)

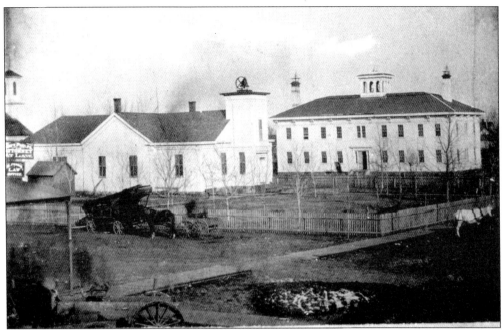

With just $150 in funds, J.B. Grinnell built a church founded upon his Congregationalist vision in 1854. Legend has it that he promised to build the church, and his congregation asked when it would be done. "This Sunday," Grinnell reportedly said, and went about collecting green wood from nearby trees. When the church was built, that wood quickly warped and left huge gaps in the walls. A separate school building was erected next. (Stewart Library Collection.)

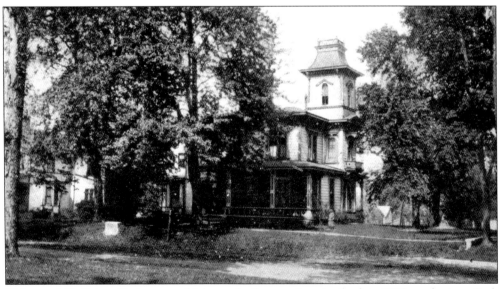

This was J.B. Grinnell's house, which was built sometime in the late 1850s and sat on Park Street just east of Central Park. Ultimately, the house was moved to a Broad Street address, then razed in the 1980s. Its original site was used to accommodate an addition to the Monroe Hotel. (Ivan Sheets Collection.)

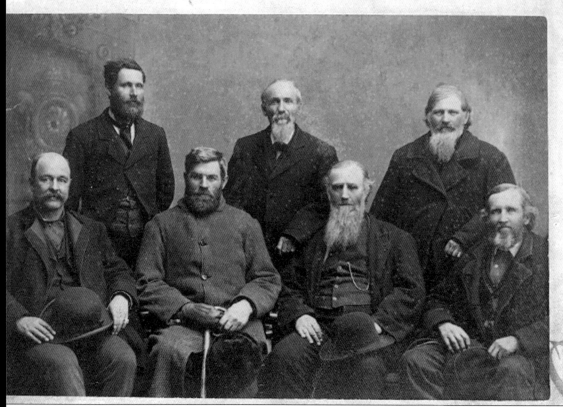

When J.B. Grinnell founded the community, he was accompanied by a group of men who helped establish the town. A quarter of a century later, some of those leaders were still prominent. Pictured in this *c.* 1880 photo are, from left to right: (front row) Ed Wright, Raymond Kellogg, Levi Grinnell (J.B. Grinnell's double cousin), and Mr. Larson; (back row) Henderson Herrick, Mr. Sergeant, and Ezra Grinnell (J.B. Grinnell's brother). (Marion Dunham Collection.)

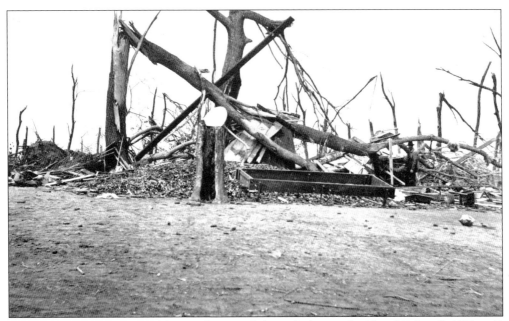

On June 17, 1882, a powerful tornado ripped through the north side of Grinnell, killing 40 people and destroying 120 buildings. The cyclone demolished both buildings on the Iowa College campus. This picture shows what remained of the West College building. In its aftermath, J.B. Grinnell personally sought out wealthy benefactors and raised $150,000 to begin rebuilding the college. (Grinnell College Archives.)

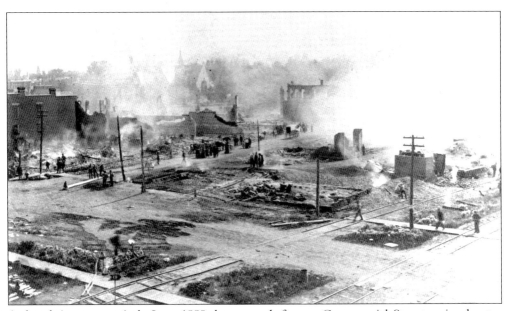

At lunchtime on a windy June 1889 day, a spark from a Commercial Street grain elevator started a fire that destroyed much of Grinnell's central business district. That block, which featured mostly wood frame buildings, was rebuilt in a fashion that would influence the community for years to come. (Grinnell College Archives.)

13

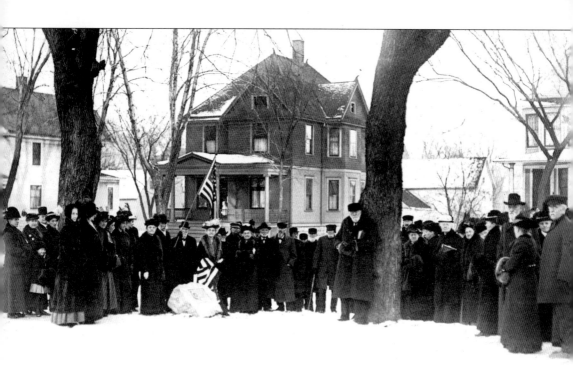

This image shows members of the Grinnell Chapter of the Daughters of the American Revolution marking the Long Home site. Inscribed on a native boulder on the west side of Broad Street, just south of Sixth Avenue, is a bronze tablet dedicated by the DAR on December 12, 1914. It reads as follows: "1854 This stone marks the site of the 'Long Home' the first house built in Grinnell—erected by the Grinnell Chapter of the D.A.R. 1914" (with a large DAR insignia). (Stewart Library Collection.)

Two

THE STREETS OF
OUR TOWN

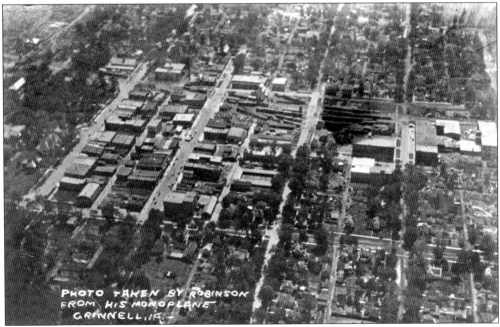

Grinnell aviation pioneer Billy Robinson did much in his career, from developing a rotary airplane engine to setting an early flight distance record. But he also gave Grinnellians a chance to see their community from a new perspective. This postcard featured a photograph of Grinnell taken from Robinson's plane, _c._ 1914. The view from the northwest clearly shows the Spaulding Manufacturing plant (building cluster at upper right), the Colonial Theatre (three-story building downtown), and an abundance of freight cars along the railroad. (Ivan Sheets Collection.)

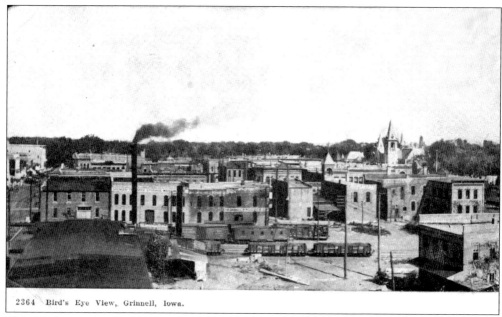

2364 Bird's Eye View, Grinnell, Iowa.

This "birds-eye view" of downtown Grinnell pre-dates Robinson's aerial shot, but gives a good glimpse of the city as a turn-of-the-century hub of commerce. Commercial Street, which is in the foreground just past the tracks, features warehouses and industry. Just to the north, the new "Phoenix Block" is developing into Grinnell's retail center. (Ivan Sheets Collection.)

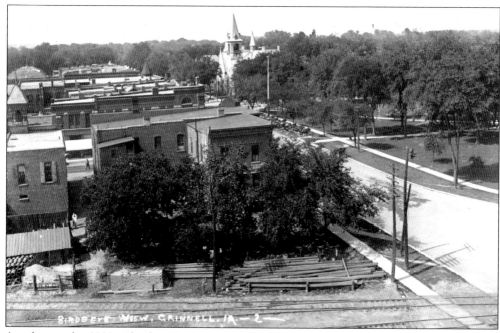

BIRDSEYE VIEW, GRINNELL, IA.—2

Another early 1900s "birds-eye view" is a look at Broad Street from the south. The Congregational "Old Stone Church" dominates the view from its location at Fourth and Broad. In the immediate foreground is the Park Hotel, which stood at the corner of Broad and Commercial. (Stewart Library Collection.)

16

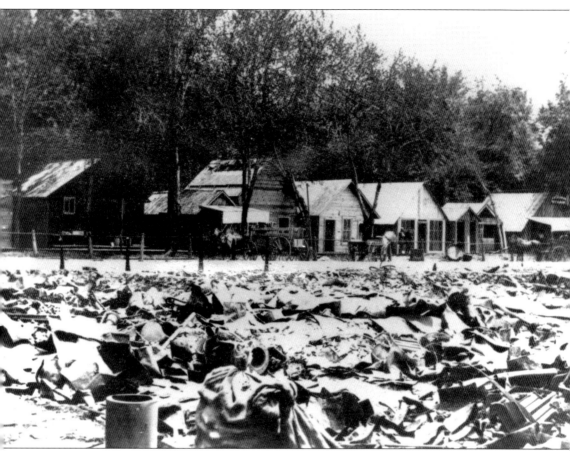

Because the great fire of June, 1889, started in the middle of the block between Main and Broad streets, it gave storeowners on Broad time to hurry back from lunch and carry all they could to Central Park. They set up shanties on the west end of the park and operated from there until the block was re-built. The block that arose on the fire site featured brick and limestone buildings designed by Josselyn & Taylor, a Cedar Rapids architecture firm. It became known as the "Phoenix Block" because it arose from the ashes of the great fire. (Grinnell College Archives.)

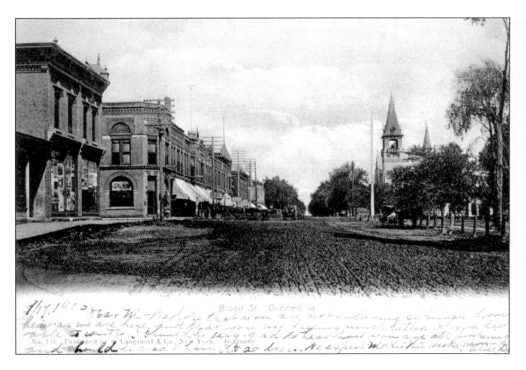

Broad St. Grinnell, Ia.

The top image is a 1906 view of Broad Street from the south. Note the dirt street, the Old Stone Church, and some of the relatively "young" trees along the west edge of Central Park. Also, the telephone poles lining the west side of the street disappear in the bottom shot, which is likely pre-1910. The poles are replaced by streetlights in the later image. Street paving began in downtown Grinnell in 1909. (Top: Marian Dunham Collection. Bottom: Ivan Sheets Collection.)

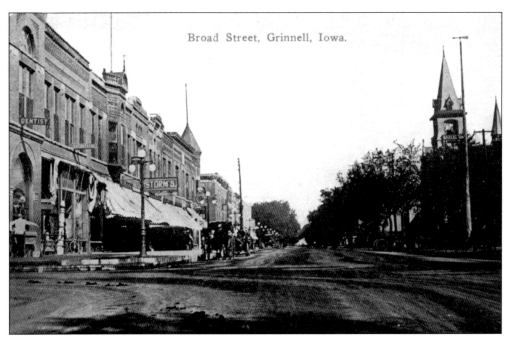

Broad Street, Grinnell, Iowa.

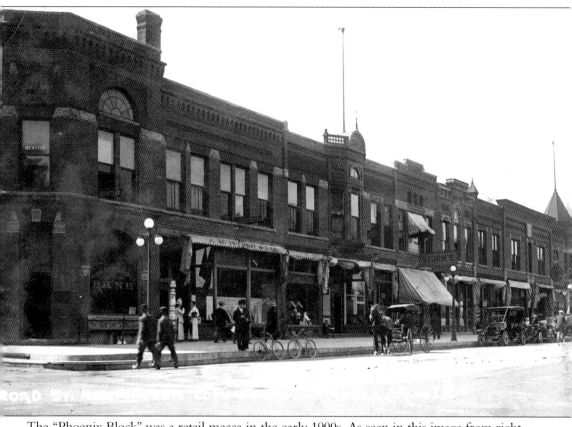

The "Phoenix Block" was a retail mecca in the early 1900s. As seen in this image from right to left, the shopping area offered clothing, hardware, shoes, a restaurant, music and jewelry, a pharmacy and bookstore, general goods, and a bank. The Merchants National Bank, on the far left, would later move one block north, into the building to be designed by Louis Sullivan. (Stewart Library Collection.)

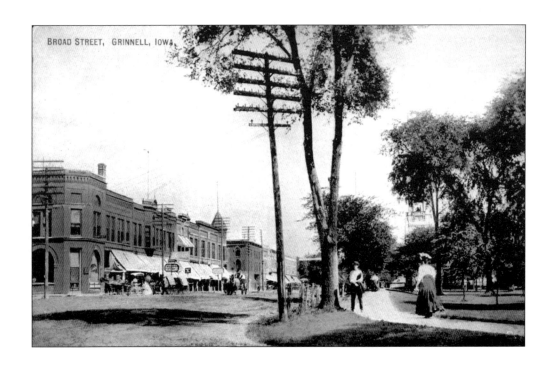

BROAD STREET, GRINNELL, IOWA.

Both images, though separated by at least a decade, show the winding curve from Third Street onto Broad and the prominent role of Central Park. The older of the two images appears above, and was used in numerous postcards in the past. Curbs (and automobiles) have arrived in the more recent card (below). (Stewart Library Collection.)

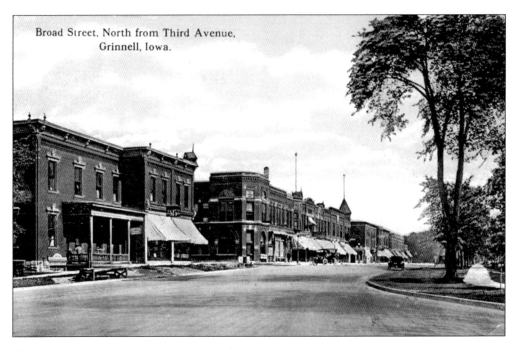

Broad Street, North from Third Avenue, Grinnell, Iowa.

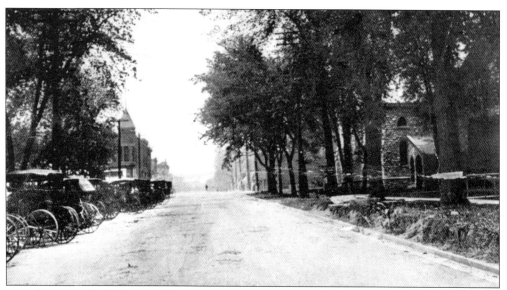

Fourth Avenue had much significance in early Grinnell. It was part of the first highway across the state, the River to River Road (Highway 6). The Road dipped down from Sixth Avenue to Fourth Avenue on the east side of town, then returned to Sixth on the western outskirts. This stretch of Fourth between Park and Broad streets shows the Old Stone Church on the right. Central Park is on the left in this 1907 image, which also features streets with curbs and buggies full of people, perhaps churchgoers. (Ivan Sheets Collection.)

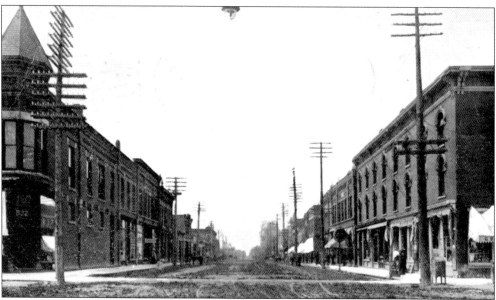

Retail along Fourth Avenue developed after Commercial and the blocks of Main and Broad just north of Commercial. But the buildings along the north side of Fourth did not suffer from fires that devastated the Phoenix Block (1889) and the middle of the block to the north (1891 and 1893). For that reason, all of the buildings on the right side of this 1907 image, with the exception of the Grinnell Block (where the former Cunningham Drug and the Sullivan Bank sit) remain standing today. (Ivan Sheets Collection.)

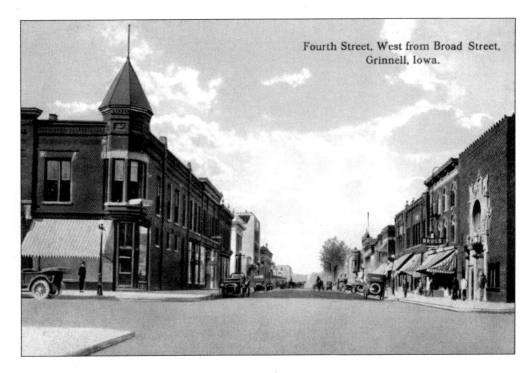

Fourth Street, West from Broad Street,
Grinnell, Iowa.

Two views of post-1914 Fourth Avenue (the Sullivan Bank has replaced the east half of the Grinnell Block). The image above is an artistic rendering of the block from the east, while the image below is a real photograph postcard of the block from the west. Note the Rexall Drug delivery truck (strategically positioned) in the street near the Rexall Store, which occupies the ground floor of the Elks Building (below, lower right). (Ivan Sheets Collection.)

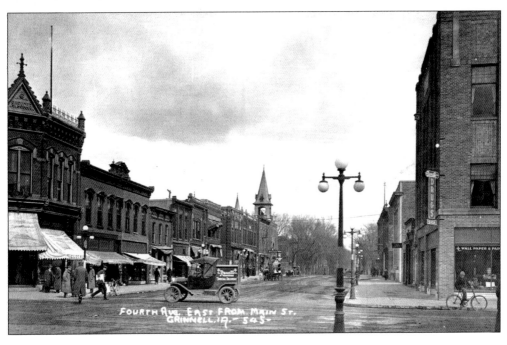

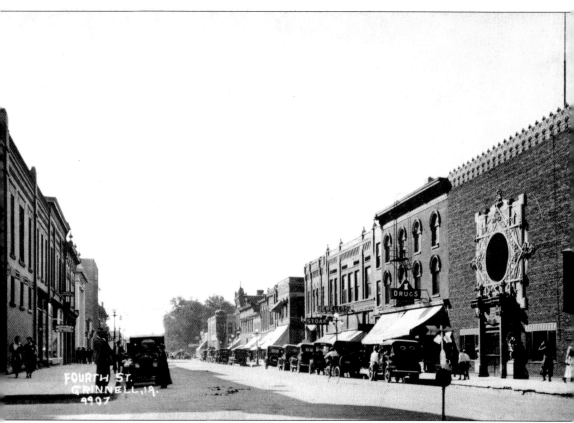

This postcard shows the new Merchants National Bank building in better detail. Famed architect Louis Sullivan, the father of the Chicago School of architecture, was hired by the bank to design a new building one block north of its office at the corner of Commercial and Broad streets. Sullivan was to design a series of banks across the Midwest known as "jewel-boxes" for their simple brick structure enhanced by striking stained-glass windows and ornate terra cotta features. The Grinnell jewel-box, built in 1914, is among Sullivan's best known. (Ivan Sheets Collection.)

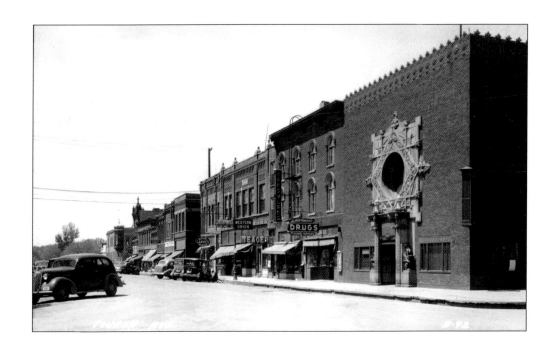

Pictured here are two more street views of Fourth Avenue from later dates. The view from the east (above) again features Sullivan's masterpiece, with a drug store and the "Candyland" next door (Mike Hotchkin Collection). The 1960s view from the west (below) is missing a landmark. The Old Stone Church, the steeple of which could be seen in earlier views at the corner of Fourth and Broad, was razed in 1951. (Ivan Sheets Collection.)

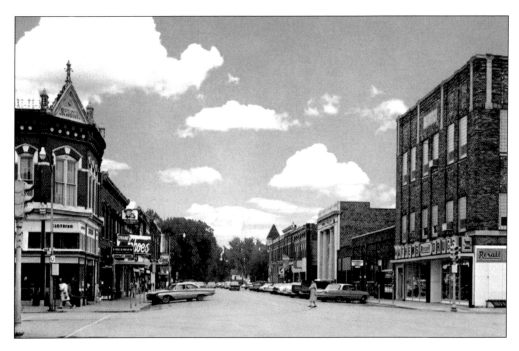

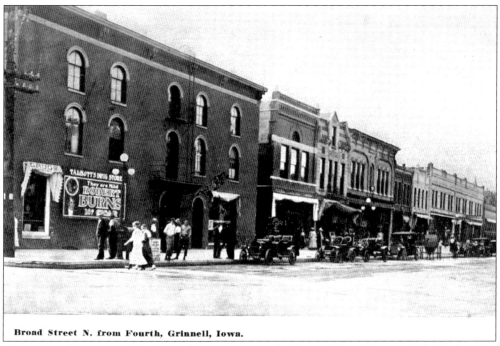

Broad Street N. from Fourth, Grinnell, Iowa.

This view of the west side of Broad Street just north of Fourth gives a wonderful look at the Grinnell Block, the building that pre-dated Louis Sullivan's bank building. The Grinnell Block and the four buildings to the north of it are no longer standing. (Mickey Munley Collection.)

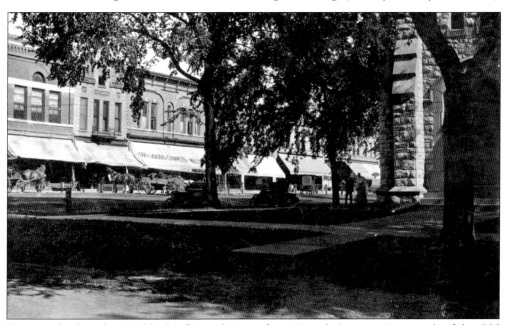

Here is a look at the 900 block of Broad Street from Fourth Avenue (just south of the Old Stone Church). The church's south entry can be seen on the right, horses and wagons are hitched on the west side of Broad, and autos are parallel-parked on the east side of the street. (Ivan Sheets Collection.)

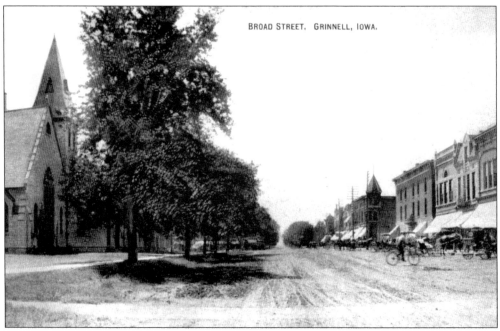

The Old Stone Church dominates the view on the left. Horses and wagons are still the primary means of transportation, though this image includes a bicyclist crossing the street. (Ivan Sheets Collection.)

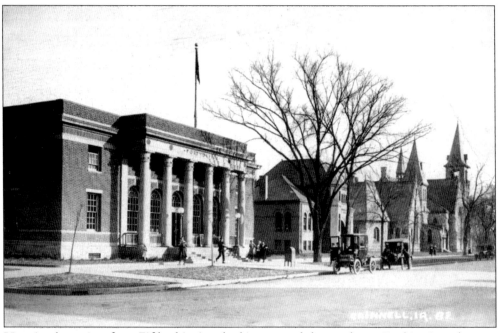

Here is a later view from Fifth, this time looking toward the southeast. In this view, the post office and Stewart Library can be seen. That dates the picture to at least 1917 (the year after the post office was completed). No horses are visible in this image. (Ivan Sheets Collection.)

North Broad Street, Grinnell, Iowa.

These two views depict the residential area of Broad Street north of Sixth Avenue. Of note in the top postcard is the mud street, as well as the hitching posts at each residence. With the exception of those features of the horse-and-buggy age, this block of Broad looks more or less the same today. The bottom postcard—which is a view looking south from Seventh Avenue—features a closer view of homes on the west side of the street, homes that continue to dominate the block today. These homes were the residences of many of Grinnell's best-known families, including both business leaders and faculty members from Grinnell College. (Ivan Sheets Collection.)

Broad Street South, Grinnell, Ia.

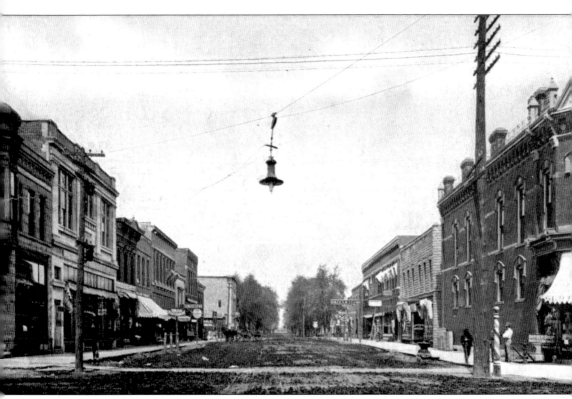

This much-used image of Grinnell's Main Street, looking north from Fourth Avenue, dates to 1907. Most of the buildings on the southern half of the block are still anchors. Missing are the Strand Theatre and the Masonic Temple, which weren't built until 1916 and 1917. (Ivan Sheets Collection.)

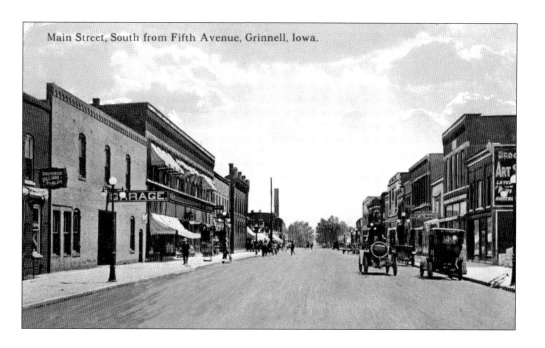

Main Street, South from Fifth Avenue, Grinnell, Iowa.

These are two very different views of Main Street between Fourth and Fifth. The first is an artistic rendering of Main Street from the north (above), *c.* 1915. Note the billiard parlor on the left and the absence of the Strand Theatre on the right. The block has the appearance of a thriving retail center. In fact, around this time, its retail success prompted business owners on Broad Street to raise $15,000 to lure the post office from Main to Broad. The other image (below) is a view from the south, probably taken a decade later. Business is still booming on Main Street, evidenced by all of the automobiles. (Ivan Sheets Collection.)

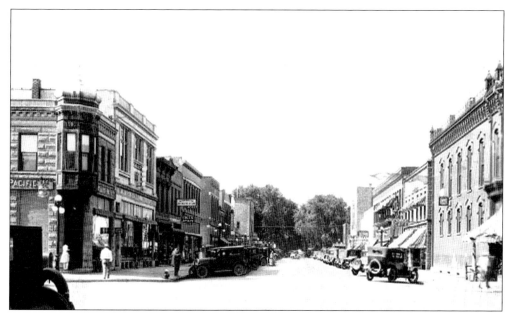

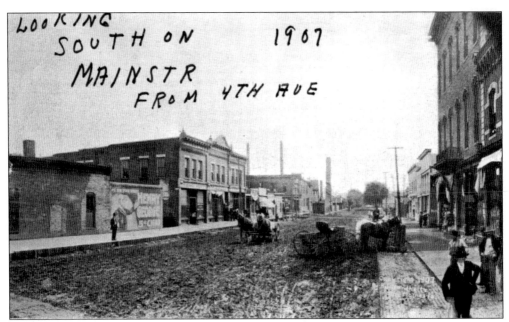

A 1907 view of the 800 block of Main Street, between Fourth and Commercial. The Preston Opera House dominates the block on the right (west), while the Water Works tower can be seen down the street on the left. (Stewart Library Collection.)

The northeast corner of Main and Fourth features the Spencer Building, which was built in 1884 to anchor the northward growth of the Central Business District along Main. Fires and the economy, however, delayed that expansion. No other building on Main Street today dates earlier than 1899. Designed by the well-known Des Moines architecture firm Foster & Liebbe, the Spencer Building was home to Stub Preston's clothing store for years. (Ivan Sheets Collection.)

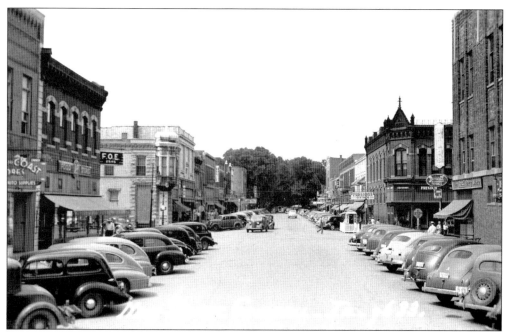

This view of Main Street looking north from Commercial features the Elks building at the southeast corner of Fourth and Main (with the Rexall Drugstore at street level). Stub Preston's store can be seen across the street in the Spencer Building, and there is an A&P grocery in the building at the southwest corner (with the Eagles Club on the second floor). Also of interest—the trees north of Fifth Avenue give that block the appearance of a forest. (Stewart Library Collection.)

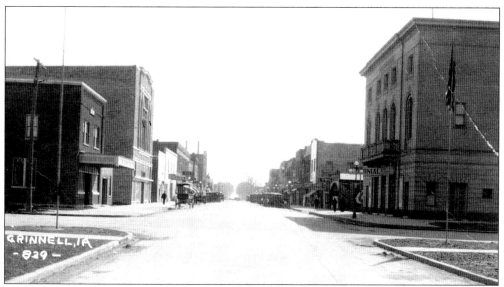

This *c.* 1918 postcard shows the Skeels Building at the southeast corner of Fifth and Main. It was a blacksmith shop when it was constructed in 1917. Of special interest is the Lyric on the right side of the street. The Lyric was a small movie theatre that operated from 1905 to approximately 1912, when the Colonial Theatre started showing films. (Ivan Sheets Collection.)

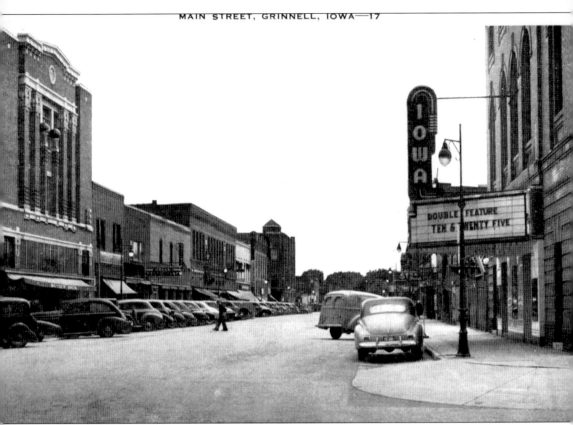

This view of Main from Fifth shows the block in the 1950s. The Colonial Theatre is now the Iowa (that's owner George Mart's car parked in front of the theatre). The Raven Restaurant can be seen on the left in the building that later served as home to JD's. (Ivan Sheets Collection.)

Three

THE SAINTS REST

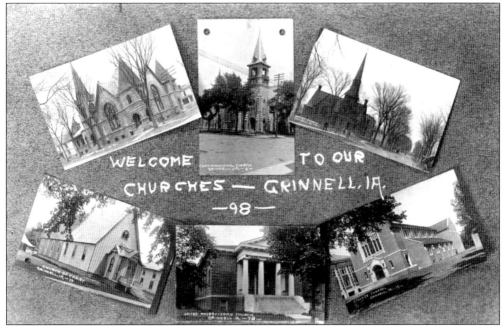

Because Grinnell was founded by men who were spiritually devout, the town's early days were heavily influenced by religion. The teetotaling nature of J.B. Grinnell and his disciples, and the constant arrival of retired ministers seeking to relocate there, did not go over well with local homesteaders. They tended to be hard-drinking and mockingly referred to the Congregationalist community as the "Saints Rest." That phrase would re-emerge several decades later as Iowa College students chafed under the strict, puritanical rules of then-president George Magoun. The town has maintained a strong, spiritual base. In 2000, the population stood at 9,107 and was served by several dozen churches. (Marian Dunham Collection.)

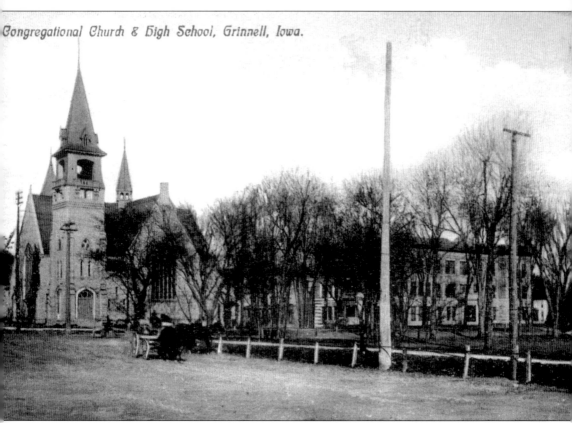

Congregational Church & High School, Grinnell, Iowa.

Built in 1877 on the site of J.B. Grinnell's original Congregational church, the Old Stone Church was the focal point of the community for years. When it was razed in 1951, a cable holding the wrecking ball broke three times as it slammed into the church's stout towers. Even after the tower was razed, wooden beams—in the shape of a cross—still stood. This view includes the high school on the same block, another part of J.B. Grinnell's plan to emphasize religion and education together. (Ivan Sheets Collection.)

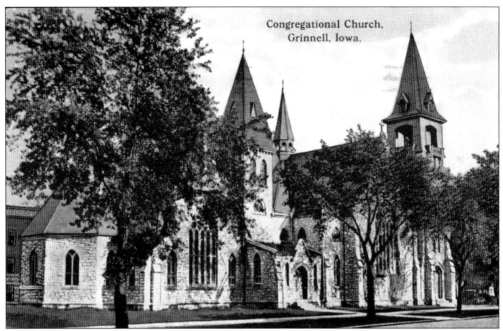

This is another view of the Old Stone Church with its stout towers. When it was built, it was the largest Congregational church between New York and California. Its sanctuary reportedly held 1,500 people. (Stewart Library Collection.)

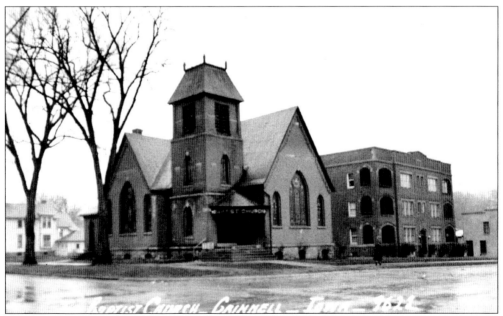

Built in 1889 at the northeast corner of Park Street and Fourth Avenue, the Baptist church was led by Rev. Thomas Brande, an influential member of early Grinnell. Baptists had built the earliest church-only structure in Grinnell 30 years earlier. The brick church building served as the focal point for the many Grinnell Baptists until 1951, when it was sold to Glad Tidings Assembly of God, then eventually razed. (Stewart Library Collection.)

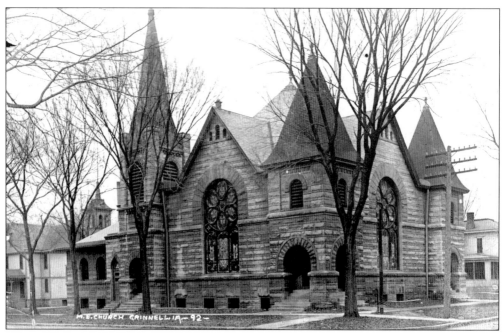

An 1895 masterpiece of Grinnell-based architect/mason/builder R.G. Coutts, the man responsible for many buildings erected between 1875 and 1923, the Methodist church is made of limestone from quarries in Indiana. Coutts considered it his crowning achievement. This postcard dates to sometime before 1920, when construction of the junior high school to the south began. (Ivan Sheets Collection.)

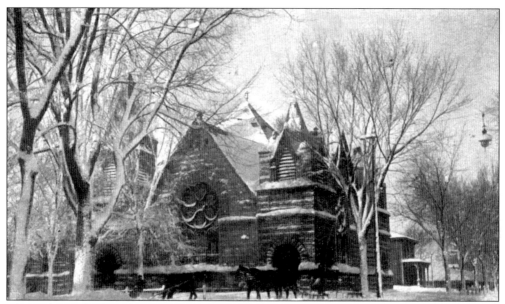

This is the Methodist Church as it appeared in the winter, *c.* 1910. (Mike Hotchkin Collection.)

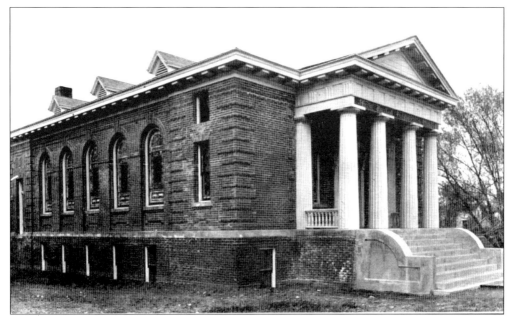

Built in 1906 at the corner of Fifth Avenue and State Street, the First United Presbyterian church was another work of R.G. Coutts. Prior to the construction of that church, Grinnell Presbyterians met first on the south end of Main Street, then at the Armory. The church was razed in 1977, due to a crumbling foundation caused by an underground creek. For that reason, the new church built on that site does not have a basement. (Marian Dunham Collection.)

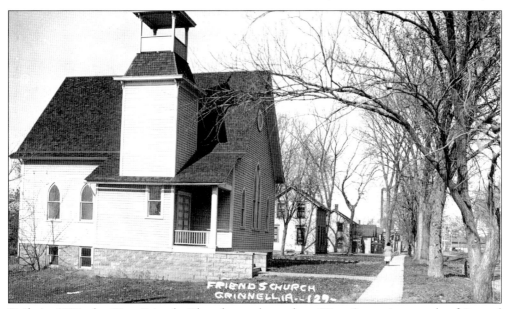

Built in 1907, the First Friends Church was located on West Street just south of Second Avenue. The house that served as the parsonage still exists, but the church itself was razed in 1972. When it was built, the church had only a sanctuary for 125 people, a pulpit, and a small room off to the side. An addition (constructed after this image was taken) added space for Sunday School classrooms. (Ivan Sheets Collection.)

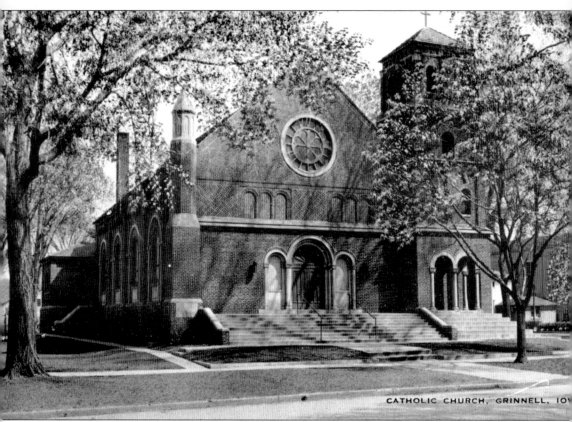

CATHOLIC CHURCH, GRINNELL, IO

The first Catholic Mass in Grinnell was reportedly said in a house near the railroad tracks in 1864. The first Catholic church, called St. Columbanus, was built in 1883 and located at Washington Avenue and Main Street. Twenty-five families made up the parish at that time. In 1919, the lot at the northeast corner of Broad Street and Fifth Avenue was purchased for a new church. An architect was not hired until 1926, but construction moved quickly and the building was dedicated in 1927. (Ivan Sheets Collection.)

Four

LANDMARKS AND
INSTITUTIONS

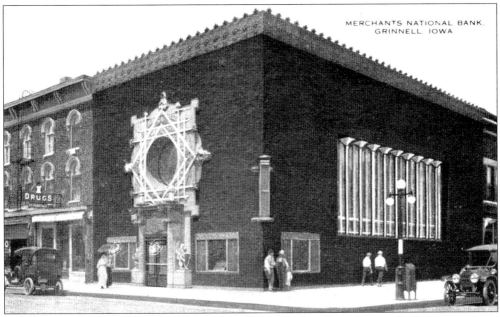

Local legend has it that architect Louis B. Sullivan purchased a yellow pad of paper at a local drugstore and sat at the northwest corner of Central Park, sketching his ideas for a bank at the opposite corner. In just three days he had designed the third of his Midwest "jewel-box" banks. With its ornate stained glass window surrounded by terra cotta and gilt, the entry of the bank dominates the building. The shape of the entrance draws comparisons to a keyhole, unlocking the solid-looking brick edifice. The building is listed as a National Historic Landmark. (Ivan Sheets Collection.)

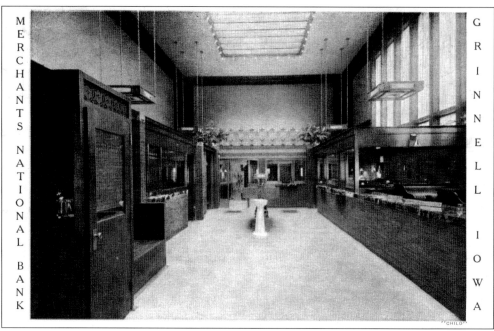

This view of the Merchants National Bank from front to back accents the natural light that floods into the building. Sullivan included three sources of natural light—an overhead skylight, the "Rose Window" included within the terra cotta entry, and the huge stained glass window on the east side (visible at right). (Ivan Sheets Collection.)

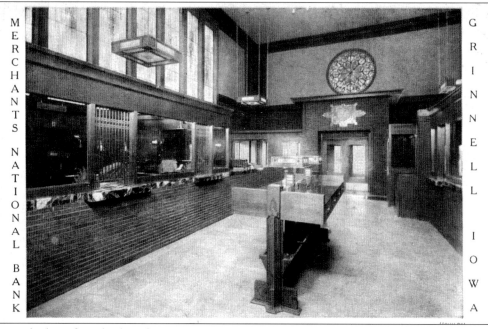

Now looking from back to front, the incredible detail of Sullivan's interior can be seen. The Rose Window appears at the top right, as well as an intricate tile design surrounding the clock just above the door. (Ivan Sheets Collection.)

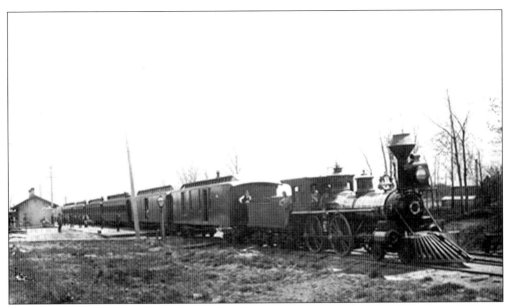

In 1854, J.B. Grinnell selected the site for his Congregationalist community based on the likelihood that east-west and north-south railroads would intersect there. But it was another nine years before the railroad actually reached Grinnell. The first train rolled into town in 1863 on what was then called the Mississippi and Missouri (M&M RR) line. (Stewart Library Collection.)

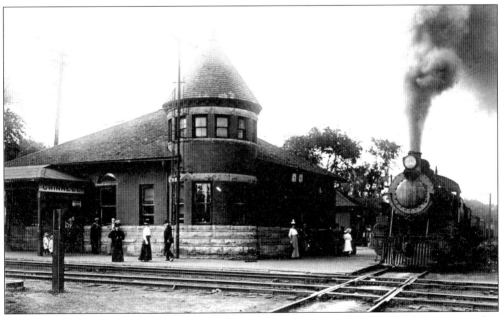

The Chicago, Rock Island and Pacific railroad depot was completed in 1893, known at that time as the "Union Depot." The first depot was a wooden shack of just 18 square feet, which served both the M&M and the Iowa Central lines. It was located north of the tracks, which was a benefit to J.B. Grinnell and others who owned property to the north. The new brick depot served the community for decades until it was abandoned in 1976. It was restored in 1993. (Ivan Sheets Collection.)

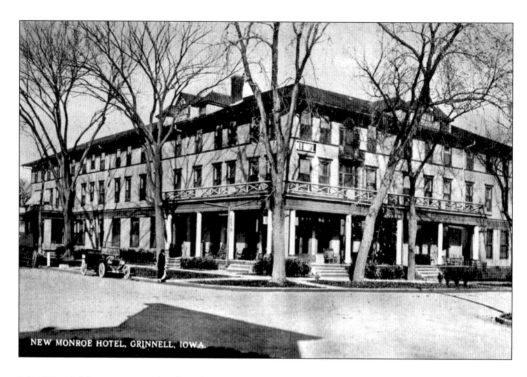

NEW MONROE HOTEL, GRINNELL, IOWA.

The Hotel Monroe was a landmark in Grinnell for some 70 years, anchoring the corner just north of the Rock Island Depot. It was an icon for travelers, college students, and local residents. Built in 1899 on land adjacent to J.B. Grinnell's house, the Monroe may have been best known for its front porch and the silver dollars embedded in the lobby floor. It also housed a bus station in later years and served as a community hub for decades. (Top: Ivan Sheets Collection. Bottom: Stewart Library Collection.)

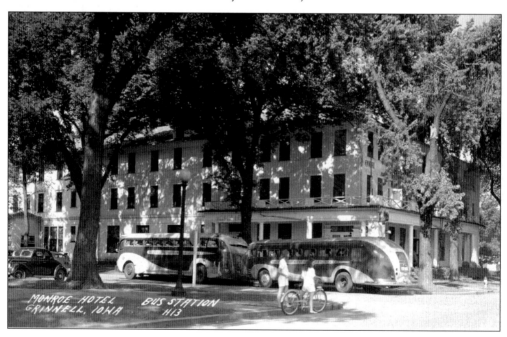

MONROE HOTEL
GRINNELL, IOWA
BUS STATION
H13

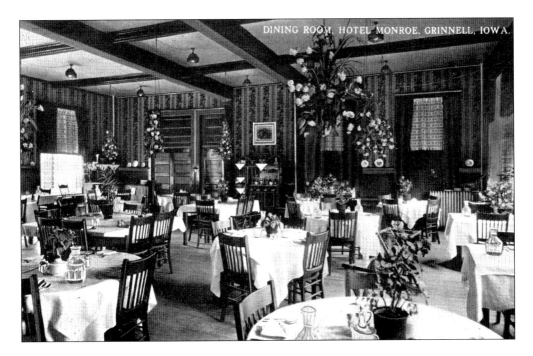

Part of the allure of the Monroe Hotel was its elegance, from the lobby to the dining room. The décor and furnishings gave the hotel the look of an upscale urban hotel, and that was fine with the many travelers who stayed there. But the Monroe was also a destination for locals, who came to eat in the hotel's elegant dining room. Local sentiment was that the steaks at the Monroe were the best in the Midwest. The Monroe was razed in 1970 after it became blighted and unsafe. (Ivan Sheets Collection.)

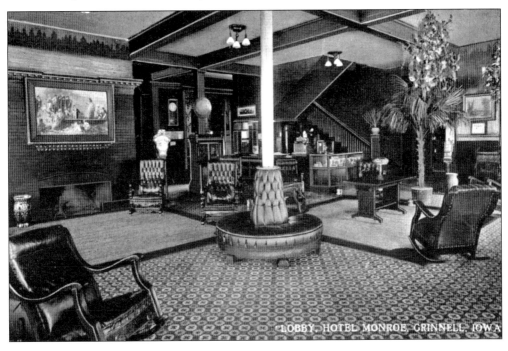

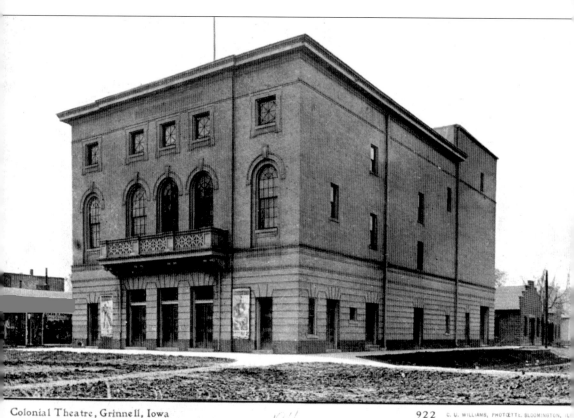

Colonial Theatre, Grinnell, Iowa 1911 922 C. U. WILLIAMS, PHOTOETTE, BLOOMINGTON, IL.

Built by the Spaulding family in 1902 at the southwest corner of Main Street and Fifth Avenue, the Colonial Theatre was three stories high with two tiers of boxes. It seated 800 people. Originally named the Opera House, it hosted theatre and vaudeville. The name changed to the Colonial Theatre in 1912 when it began showing movies. It was purchased in 1935 by George Mart, who also owned the Strand Theatre. It was razed in the 1970s. (Ivan Sheets Collection.)

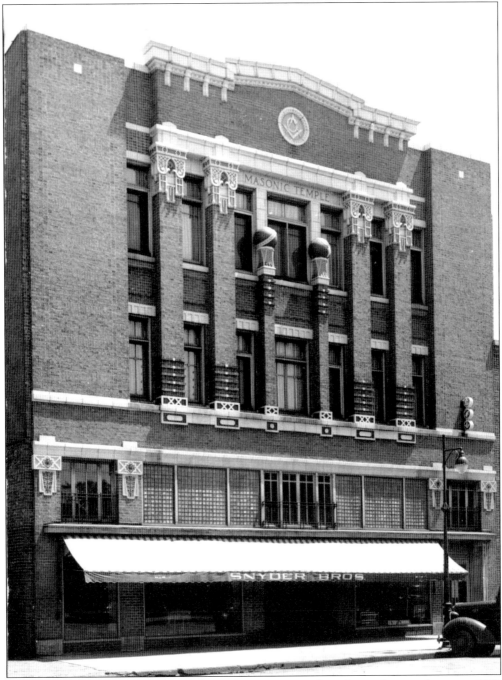

The Masons of the Grinnell Hermon Lodge met in a series of rented spaces between 1877 and 1918. Members decided in 1913 to buy a lot on Main Street for $5,000. They hired a Des Moines architect, Frank Wetherell, to design a new Masonic Temple. The first meeting in the grand building was held in May, 1918. The street level space has housed retail tenants from that day. The second and third floors are used for events and meetings of the Masons. (Stewart Library Collection.)

The southeast corner of Main Street and Fourth Avenue was the original site of the Candyland, which eventually moved across the street and to the east. The owners of the property began negotiating with the local Rexall drugstore to be the anchor tenant in a new building they wanted to locate on that site. The local Elks lodge heard of the plans, and offered to lease the upper two stories if the building was three stories high. The structure itself is a wonderful example of a 1915 commercial structure with some Art Deco embellishments. It housed the Rexall drugstore for years, though the Elks eventually moved into a new building two blocks to the south. (Ivan Sheets Collection.)

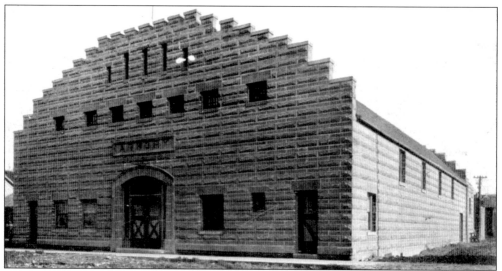

The National Guard Armory on Fifth Avenue was built in 1906 (by R.G. Coutts) and dedicated in 1907, replacing the original armory, located at the corner of Fourth Avenue and State Street. The armory was home to Company K of the Iowa Volunteer Infantry. It was also used for Grinnell College women's basketball games, a grocery store, and has been the home of one of Grinnell's best-known restaurants for years. (Mayor Gordon Canfield Collection.)

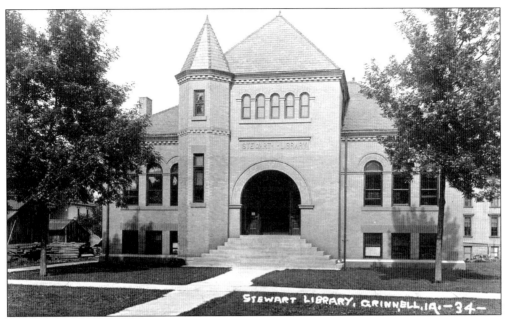

Joel Stewart, a local farmer, banker, and state legislator, funded the construction of the library in 1901. Prior to that, library services were offered out of lease space first on Broad Street, then on Main. Although the architect of this building is not known, legend has it Stewart helped with the design and supervised construction. The dominant feature of this is the castle-like tower which houses a solid oak spiral staircase. Prior to the addition of an elevator, this was the only way to get to the attic. At one time, the basement was the home of an industrial school, and was later used by the Christian Science Society. (Stewart Library Collection.)

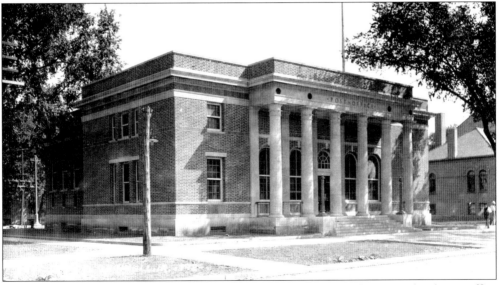

Built in 1916, this post office building on Broad Street replaced a basement-level post office in the Spaulding Building on Main Street. Businessmen on Broad Street raised $15,000 to purchase the lot and convinced the U.S. Postal Service to build on that site, hoping it would improve business on their block. (Stewart Library Collection.)

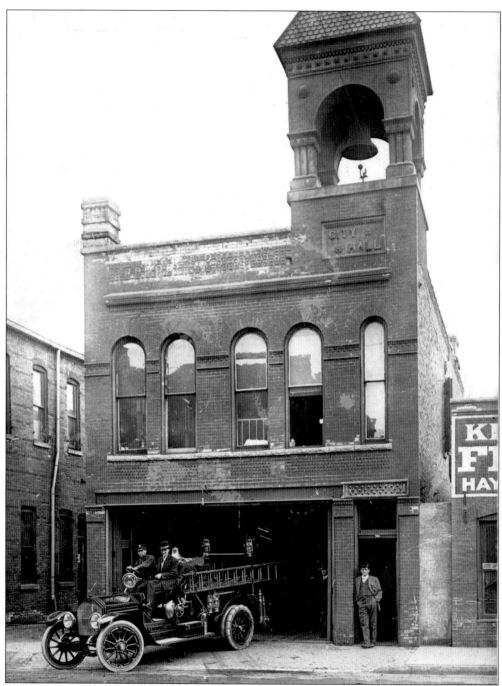

It is only somewhat ironic that in the years immediately following the 1889 fire which devastated much of Grinnell's central business district, the city's new fire station should be located near the spot where that fire began. At the time of this photo, the building housed City Hall (which would move across the street when the Merchants National Bank moved out of the Cass & Works building). Built on Commercial Street, this two-story firehouse stood until the 1960s. (Stewart Library Collection.)

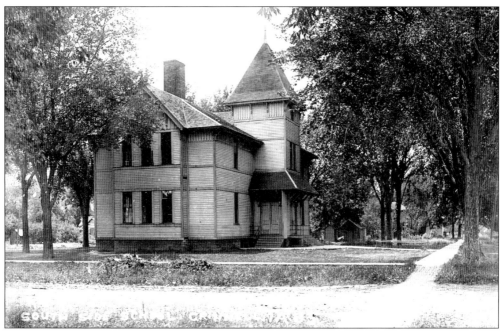

Built in 1877, the South Side School stood at the corner of Hamilton and Broad streets. The fourth school building in Grinnell, it was replaced in 1917 by Davis School. (Stewart Library Collection.)

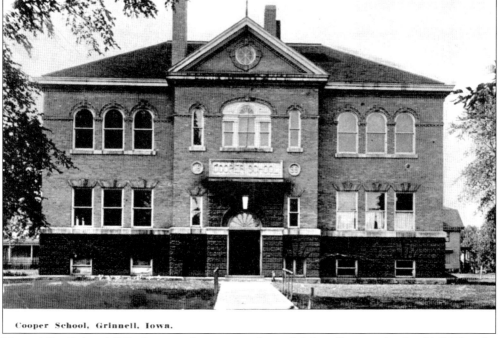

Cooper School, Grinnell, Iowa.

Named for Colonel S.F. Cooper, the commandant of Grinnell troops in the Civil War, the 1899 R.G. Coutts-built Cooper School stood at the corner of Sixth Avenue and Elm Street. (Stewart Library Collection.)

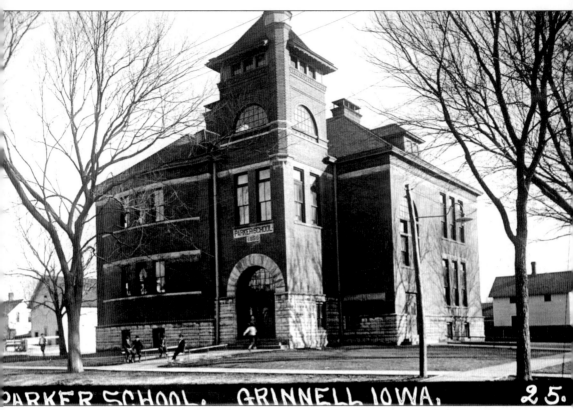

PARKER SCHOOL. GRINNELL IOWA. 25.

Built in 1896, Parker School stood at the corner of Spring Street and Sixth Avenue. It replaced the old Northwest School which was destroyed by a fire. The school was named for Grinnell's first superintendent, L.F. Parker. Parker was primarily a professor of Greek, Latin, and History at Iowa College, a confidant of J.B. Grinnell, and a friend of the abolitionist John Brown. (Stewart Library Collection.)

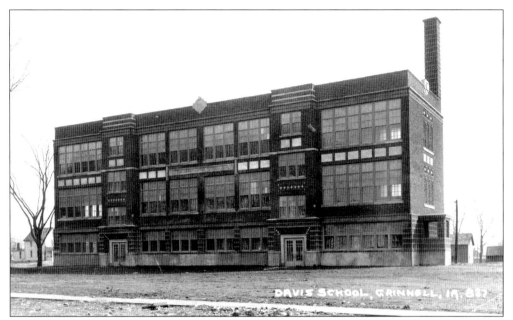

Built in 1917 on Hamilton Avenue (replacing the South Side School), Davis School was named for Lizzie and Edna Davis, members of the Grinnell class of 1877. The sisters went to the Iowa Normal School (later Iowa State Teachers College, then the University of Northern Iowa) and returned to spend the rest of their careers teaching in Grinnell. (Stewart Library Collection.)

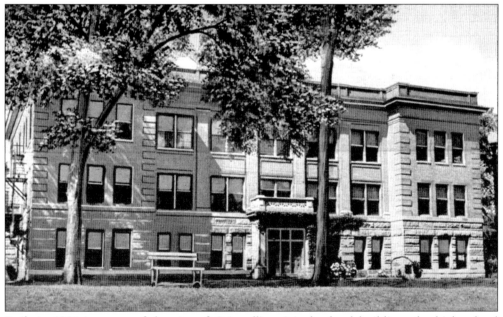

Built in 1904 just east of the site of Grinnell's original school building, the high school anchored the corner of Park Street and Fourth Avenue. In 1921, a junior high was added to the north. The building became part of the junior high when the new high school was built in 1961, and it was eventually razed in the 1970s. The community center was developed on that site, incorporating the old junior high. (Ivan Sheets Collection.)

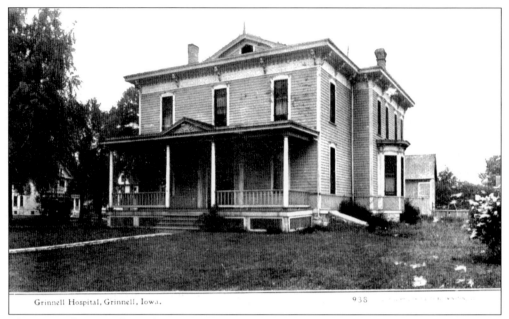

Grinnell Hospital, Grinnell, Iowa.

The Grinnell Hospital was the city's second, built in 1908 at the corner of Elm Street and Sixth Avenue. The first hospital was operated from 1901–1904 out of the home of Dr. P.E. Somers, 1127 Park Street, which also included a surgery and patient rooms. (Ivan Sheets Collection.)

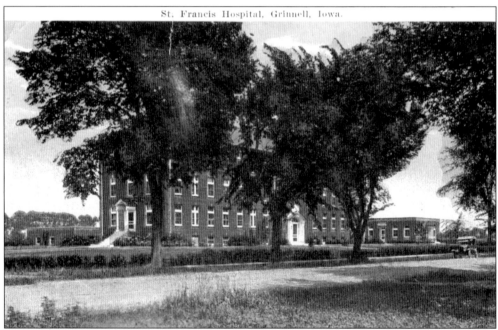

St. Francis Hospital, Grinnell, Iowa.

Dedicated in 1919, St. Francis Hospital was located on the east side of town near the current St Francis Manor. It merged with the Community Hospital in 1967 and was razed in 1977. That demolition was reportedly very difficult, due to the building's solid construction. (Ivan Sheets Collection.)

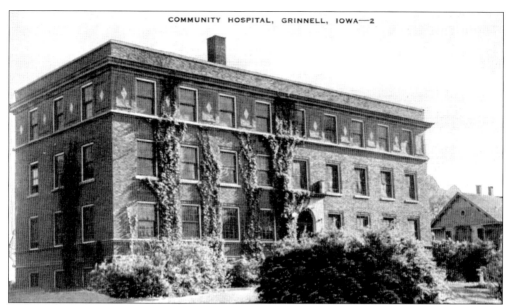

Dedicated in 1919 on the site of the current Grinnell Regional Medical Center, the Community Hospital replaced the Grinnell Hospital, which was too small to handle the growing needs of the town. In 1967 it merged with St. Francis Hospital and became Grinnell General Hospital. The original 1919 building was razed in 1983. The small building to the right was known as the "Pest House," where patients with communicable diseases were treated. (Ivan Sheets Collection.)

A "clubhouse" of sorts for area youths, Uncle Sam's Club was a place to go for fun and recreation based on the "neighborhood house" model. Originally located at First Avenue and Pearl Street, a permanent "Clubhouse" was built in 1902 across the tracks south of the Spaulding factory (Third and Pearl). Uncle Sam's Club—named for an Iowa College student named Sam—was an early example of town-gown cooperation, with college students volunteering to work with the area children. The club was quite organized, with classes, sports, and other activities. Uncle Sam's closed in 1987 and was razed in 1988. (Mickey Munley Collection.)

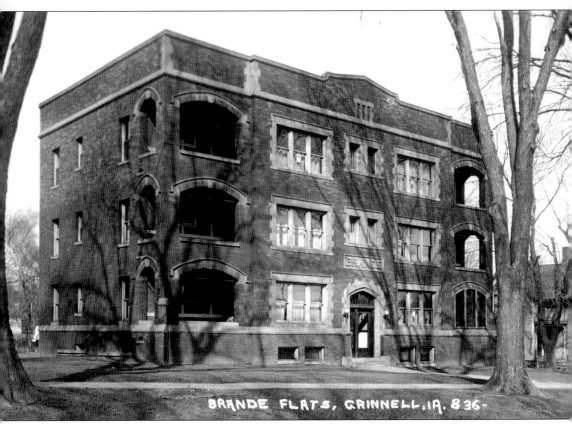

BRANDE FLATS, GRINNELL, IA. 8 36 -

Originally the site of the Baptist Church parsonage, the property was always linked to Reverend Thomas Brande, the first pastor. Legend has it that when the apartments were built in 1909, they included a first-floor unit for Isabella Brande, the elderly widow of Thomas Brande. She could open her windows to the church next door and listen to Sunday services from her apartment. (Stewart Library Collection.)

Five

PARKS AND
PUBLIC PLACES

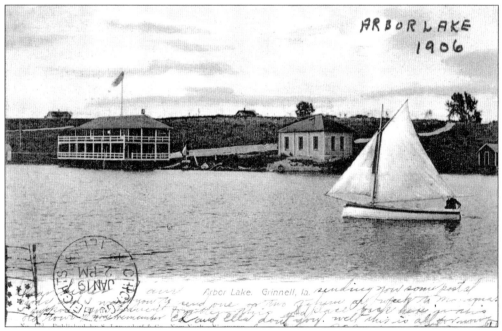

In 1903, the Grinnell Soft Water Company, in cooperation with the Ladies Cemetery Association, dammed a small tributary on the southwest edge of Grinnell and created Arbor Lake. The lake was built to provide soft water for the boiler system that provided heat to downtown Grinnell and Iowa College. (Stewart Library Collection.)

In addition to the soft water uses for the lake, Arbor Lake also offered recreational opportunities. A beach and pavilion on the east side of the lake were heavily used for many years. The beach and pavilion no longer remain. (Grinnell College Archives.)

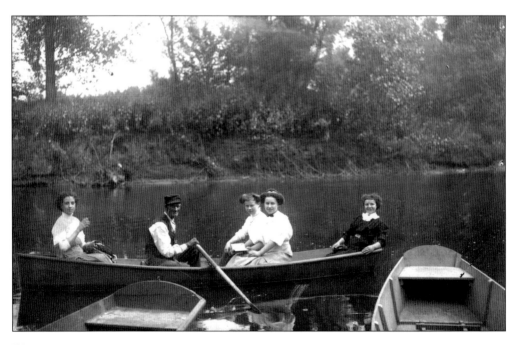

"JACK FROST" CITY PARK GRINNELL, IA. -147-

When J.B. Grinnell laid out a plan for the town that would bear his name, the center block was a park, Central Park. Grinnell took the block to the east, dedicated the block to the north for church and school, and then parceled the rest of town to his fellow pioneers. (Grinnell College Archives.)

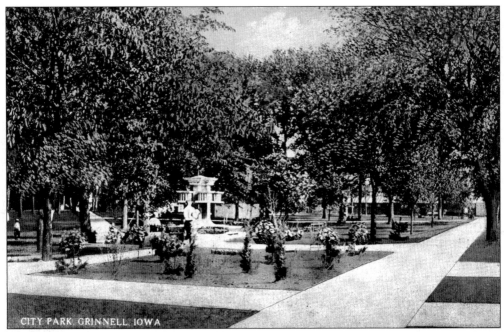

CITY PARK, GRINNELL, IOWA

For many years, the focal point in Central Park was the E.W. Clark Memorial Fountain, designed by famed architect Walter Burley Griffin and built for $900. Clark was one of the first physicians in Grinnell, a mayor, and state senator. He was responsible for, among other things, creating city water and sewer systems and supporting the fire department. (Mickey Munley Collection.)

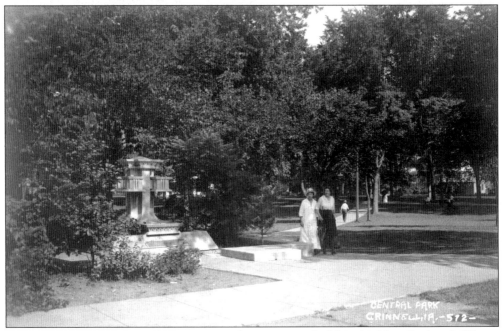

CENTRAL PARK
GRINNELL, IA. -572-

B.J. Ricker, an executive at the Morrison Glove Factory, had hired Walter Burley Griffin to design a Prairie-style home at the corner of Tenth and Broad. It was Ricker who suggested that Griffin should also design the fountain honoring former mayor Clark. (Ivan Sheets Collection.)

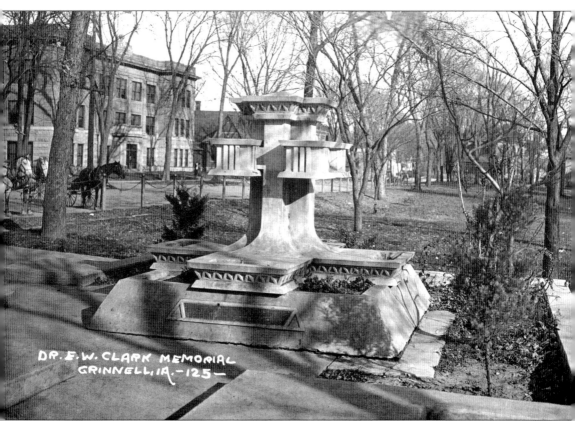

DR. E.W. CLARK MEMORIAL
GRINNELL, IA. -125-

The Clark Memorial Fountain, built in 1911, stood for 43 years in Central Park, first near the northeast corner of the park then after 1931 near the center of the park. Architect Walter Burley Griffin was quite active in Iowa during these years, designing the fountain and the B.J. Ricker house in Grinnell. He also developed an entire Prairie School neighborhood in Mason City, naming it "Rock Crest & Rock Glen." Griffin and his wife, Marion Mahoney Griffin, were former employees of Frank Lloyd Wright's architecture firm in Chicago and were prominent players in the growth of the Prairie School. (Marian Dunham Collection.)

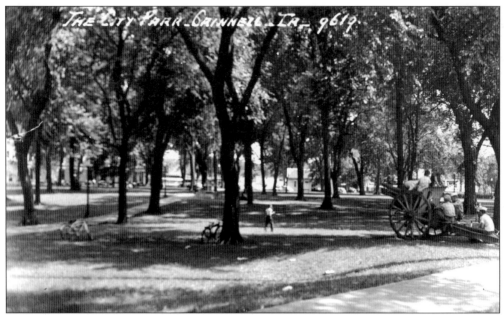

At one time, Central Park was home to an authentic World War I cannon, a "French 75." The only building that has ever stood in the park is the current Veterans Memorial Building, which houses the city's Veterans Commission. (Ivan Sheets Collection.)

Hazelwood Cemetery was created thanks to J.B. Grinnell's contribution of 13 acres on the southwest side of town in late 1854. The land was covered with clumps of hazel, hence the name. The cemetery was needed following the deaths of four early settlers. The first person buried in the cemetery was Christina Patterson, who died early in 1855. Three individuals who died in late 1854 were initially buried on their respective homesteads, but later re-interred at Hazelwood. (Stewart Library Collection.)

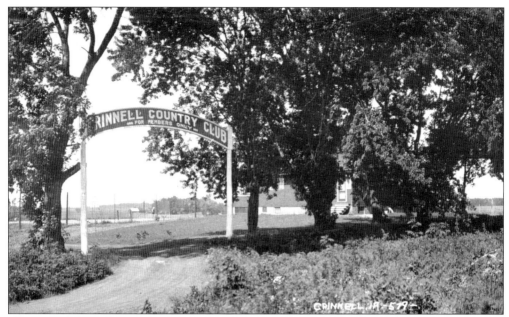

Founded in 1899 by 14 charter members, the Grinnell Country Club was the product of college faculty who had encountered the game of golf during trips to Europe. Chemistry Professor W.S. Hendrixson was at the forefront of this organization, and apparently played a role in every aspect of its founding. His name appears on almost every account. (Stewart Library Collection.)

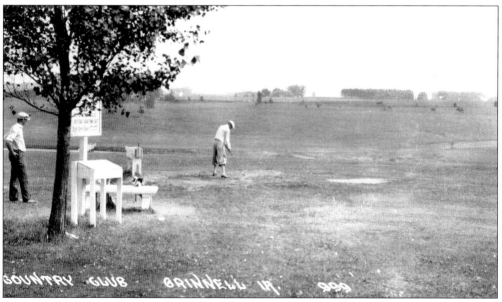

Country Club founders purchased land on the north side of the college campus edge of town known as Sanders Pond, a gently rolling meadow. On that land they designed a nine-hole golf course. An additional five holes were laid out on the college campus for women members of the club. Those holes were of "more easy access," according to local reports. (Marian Dunham Collection.)

Scene near Grinnell, Iowa.

"Scene Near Grinnell" is another pastoral—though thoroughly unidentifiable—image. The road indicates it could be a section of the River to River Road, possibly west of town. (Mickey Munley Collection.)

Six

BUSINESS AND
INDUSTRY

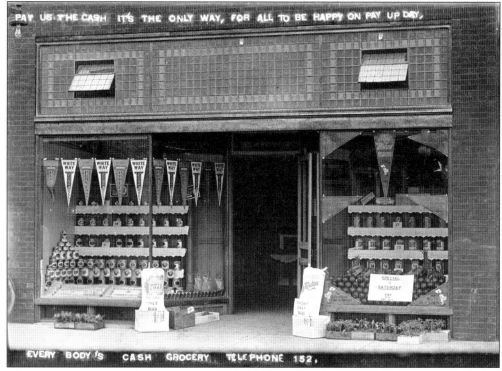

This image of Everybody's Cash Grocery was taken on a Saturday when 50-pound bags of King Midas flour ("the Highest Priced Flour in America") were selling for $1.88. The other Saturday special is 30¢ for a dozen potatoes. Though no records exist, it's likely this business was located on Broad Street. (Mickey Munley Collection.)

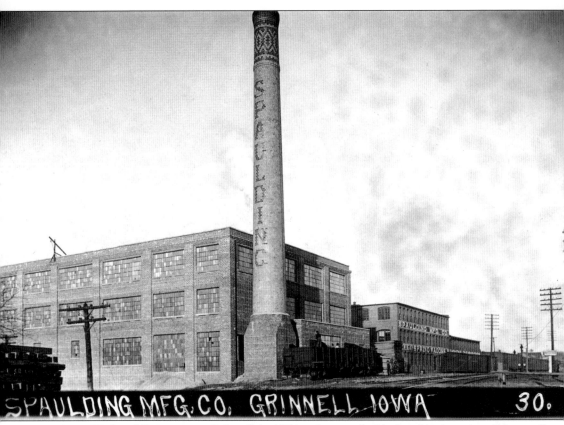

SPAULDING MFG. CO. GRINNELL IOWA 30.

Henry W. Spaulding came to Grinnell in 1876 and opened a blacksmith shop that did a small business in buggy construction. During his first ten years, he went from producing 15 buggies a year to over 800. Production and sales continued to climb between 1890 and 1903, finally reaching the 10,000 mark. The age of the automobiles, however, was looming and Spaulding began building autos in 1909. (Stewart Library Collection.)

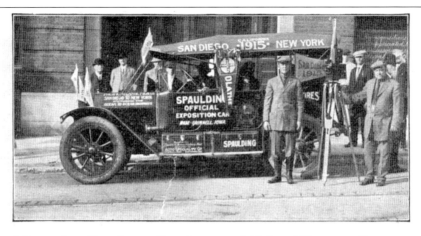

"*Spaulding San Diego Distributor and Official Panama Exposition Car logging and filming Ocean to Ocean Highway from San Diego, California, to New York.*" **SPAULDING MFG. CO.**
GRINNELL, IOWA

Spaulding automobiles made a quick mark on the industry, taking a prominent place among other early manufacturers. The 1915 card (above) shows a Spaulding auto featured in a cross-country expo. The 1913 image (below) features the Spaulding Racer that defeated the "fast" mail train in a race between Davenport and Council Bluffs along the "River to River" road (now Highway 6). The Racer set a speed record during that race that was the source of great local pride. (Ivan Sheets Collection.)

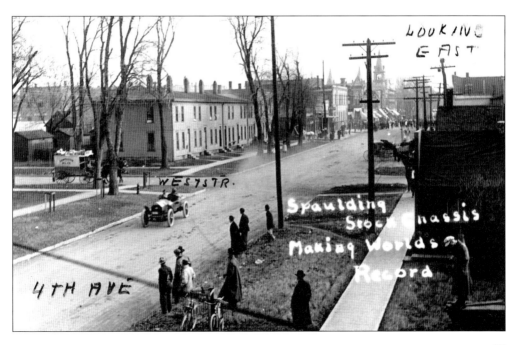

The Spaulding Manufacturing Company had a tremendous impact on Grinnell. It employed hundreds of workers, enjoyed a national prominence with its buggies and then its autos, and the family was greatly involved in the community. H.W. Spaulding was a college trustee, a mayor, and a state senator. The Spaulding family was responsible for key buildings in the community, including the Colonial Theatre, the Spaulding Block (on Main Street), and the fabulous Spaulding Home at the northwest corner of Sixth and Main as well as three other houses in the 1100 block of Main. Spaulding buggies were a staple of Grinnell parades and special events for decades. (Ivan Sheets Collection.)

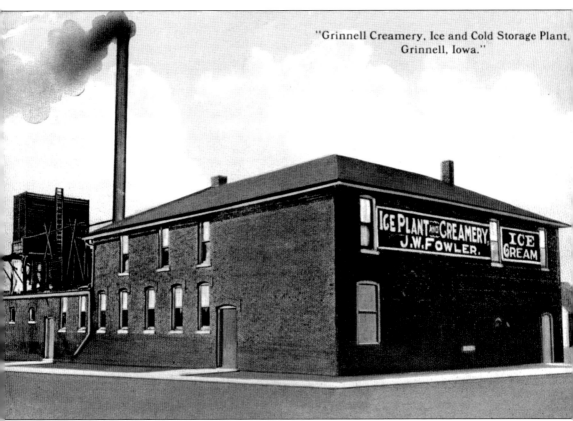

"Grinnell Creamery, Ice and Cold Storage Plant, Grinnell, Iowa."

Established in 1902 by J.W. Fowler, the Creamery was a prolific business. In 1905, it was producing 1,800 pounds of butter, 250 quarts of milk, and up to 40 gallons of cream every day. (Ivan Sheets Collection.)

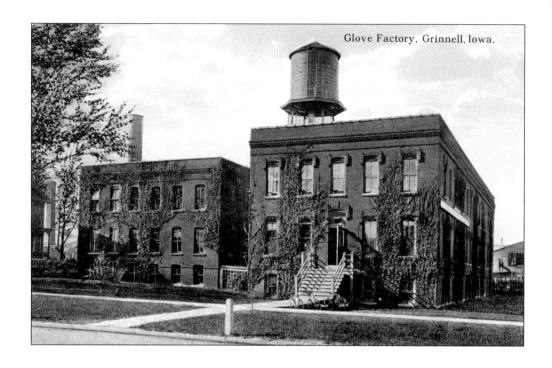

Glove Factory, Grinnell, Iowa.

Built in 1895, the Morrison Glove Factory employed thousands of workers over the years. In fact, F.W. Morrison started a leather business at Sixth and State in 1856, and the business boomed from there. Located on Broad Street just south of the railroad tracks, the Glove Factory actually featured two buildings. On the right of the top image is the original 1895 plant, on the left is a 1906 addition prompted by strong sales. The sales pitch on the bottom targets male glove buyers. (Top-Ivan Sheets Collection, bottom- Mickey Munley Collection.)

MORRISON, McINTOSH & CO.
GLOVE MAKERS
GRINNELL, - IOWA

SAY--

Dad's coming with "Grinnell'
Gloves! Wait for him,--he says
prices are right. Ask about
the new Factory,--it's a big
one. This is Dad.

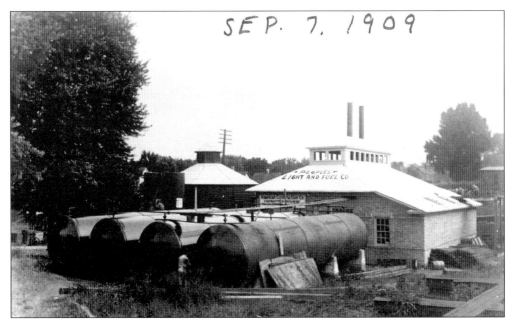

Grinnell's first gas plant, People's Light and Gas was established in 1909 and began piping natural gas throughout the community. A 1923 description of the plant, located south of the Chicago, Rock Island and Pacific railroad tracks near State Street, indicates it initially served 400 customers and had doubled its business within 14 years. In that year, there were 15 miles of gas lines throughout the community. (Stewart Library Collection.)

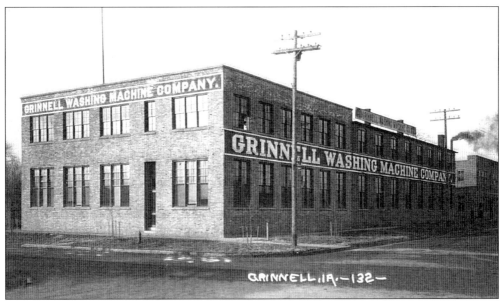

Once one of Grinnell's premier manufacturers, the Grinnell Washing Machine Company was located at the corner of Third and Main, the site of the current Elks Lodge. A strong competitor to Newton-based Maytag Corporation, the Grinnell Washing Machine Company produced an early engine-driven washer, as well as vacuum cleaners. The company flourished until the Depression, and went out of business in 1938. (Stewart Library Collection.)

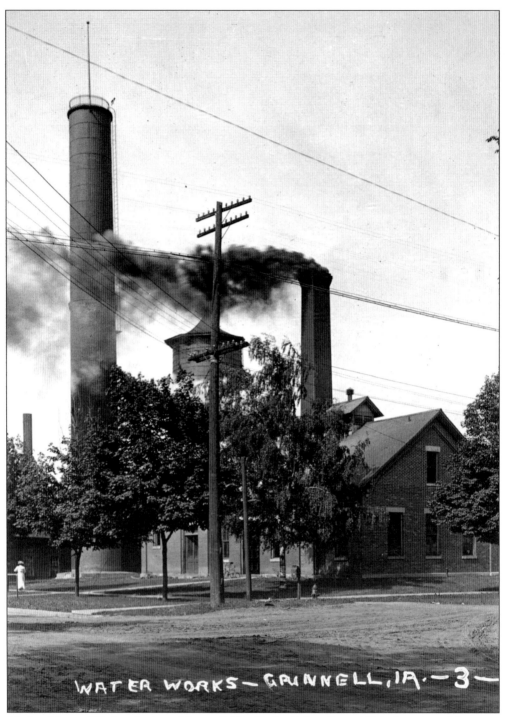

WATER WORKS — GRINNELL, IA. — 3 —

Under Mayor J.R. Lewis then Mayor E.W. Clark, Grinnell established a city-wide water system between 1892 and 1895. That included the digging of a deep-water well, which was housed within a water works facility built in 1894, and the city's first water tower, standing 106 feet to boost water pressure. (Ivan Sheets Collection.)

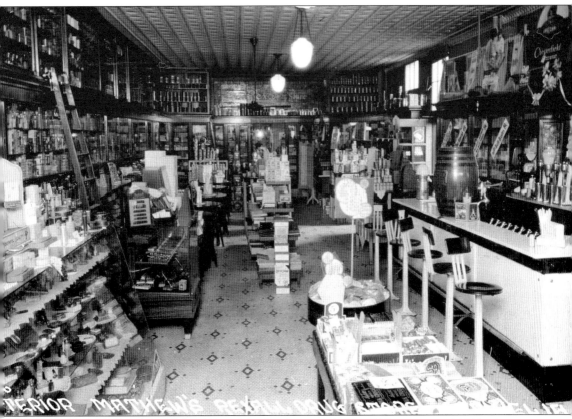

Grinnell pharmacist Roy Bates affiliated his business with Rexall Drug around 1910, then leased the ground floor of the new building erected at Fourth and Main by the Manly family (which also housed the Elks Lodge). Bates eventually got out of the pharmacy business and opened a flower shop. He sold the Rexall to Earl Mathews, and this is a look inside Mathews' store. The soda fountain at the right was the first drugstore soda fountain in Grinnell. (Mike Hotchkin Collection.)

Located at 929 Broad Street, the Benson and Kibby furniture and undertaking business was located in another structure built by R.G. Coutts. This 1910 promotional piece shows them to have an understanding of modern-day retail schemes that emphasize humor. (Stewart Library Collection.)

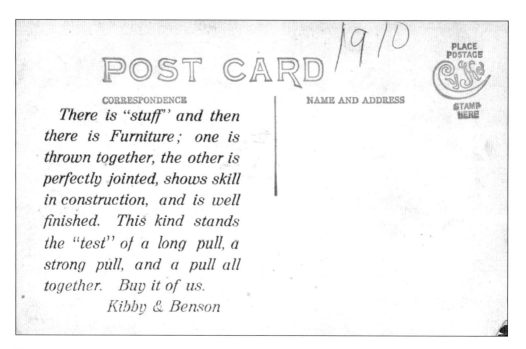

POST CARD *1910*

PLACE POSTAGE

CORRESPONDENCE

NAME AND ADDRESS

STAMP HERE

There is "stuff" and then there is Furniture; one is thrown together, the other is perfectly jointed, shows skill in construction, and is well finished. This kind stands the "test" of a long pull, a strong pull, and a pull all together. Buy it of us.

Kibby & Benson

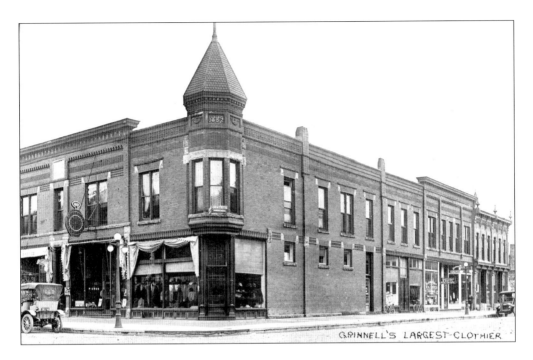

GRINNELL'S LARGEST CLOTHIER

The southwest corner of Fourth and Broad had a long history as a retail anchor. Rinefort's, "Grinnell's Largest Clothier," used this postcard as an early example of direct mail marketing. The corner from which it operated was once known as Herrick's Corner—named for the hardware business operated by S.H. Herrick. It was his father for whom Herrick Chapel on campus was named. Those businesses were destroyed in the fire of 1889—it was remembered as "Herrick's Bonfire" for the height of the flames. (Mike Hotchkin Collection.)

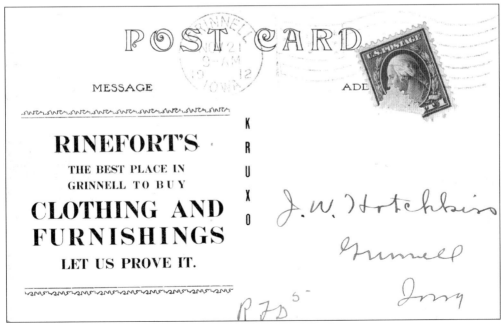

POST CARD

MESSAGE

ADD

RINEFORT'S

THE BEST PLACE IN
GRINNELL TO BUY

CLOTHING AND
FURNISHINGS

LET US PROVE IT.

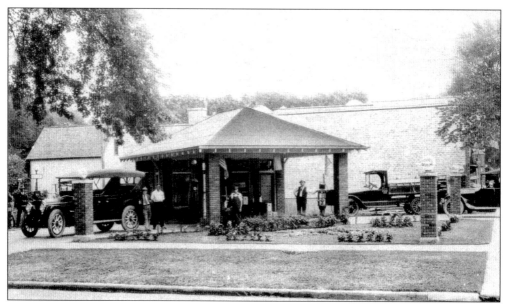

Located at the northwest corner of Fifth and Main, the Manhattan Oil Co. was a good example of an early service station. Built in 1916 as a White Star Oil Company station, it was Grinnell's first modern filling station. It became a Standard Oil station in the 1930s. (Mickey Munley Collection.)

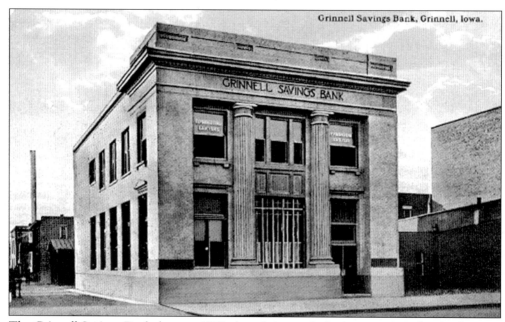

The Grinnell Savings Bank dates to 1877, though it wasn't the community's first bank. (First National Bank of Grinnell, first known as Thomas Holyoke & Company, was founded in 1870.) Among the early stockholders at Grinnell Savings Bank was Henry Lawrence, one of the first settlers to arrive. A friend of J.B. Grinnell, Lawrence also served as secretary-treasurer of the Grinnell-Montezuma railroad. The Grinnell Savings Bank building on Fourth Avenue—built in 1914—is now the home of Grinnell State Bank. (Ivan Sheets Collection.)

Seven

"A NEW ENGLAND COLLEGE IN THE WEST"

Founded in 1846 in Davenport, Iowa, by a band of Congregational ministers, Iowa College was lured to Grinnell in 1859 by J.B. Grinnell. Grinnell offered Iowa College trustees $35,000 and an environment more compatible with their Congregationalist beliefs. (Grinnell College Archives.)

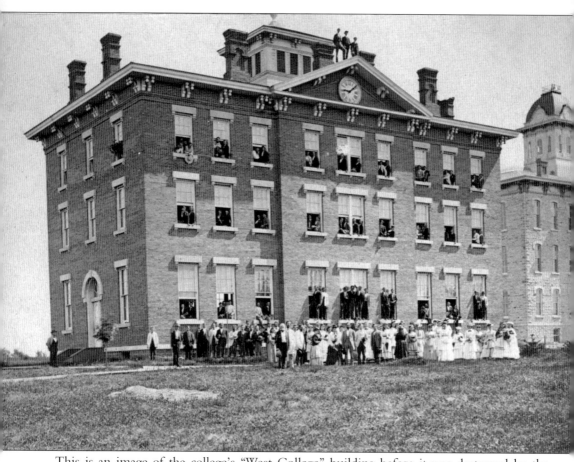

This is an image of the college's "West College" building before it was destroyed by the cyclone of 1882. There were 354 students at the time, including 29 students who were to graduate that June. (Grinnell College Archives.)

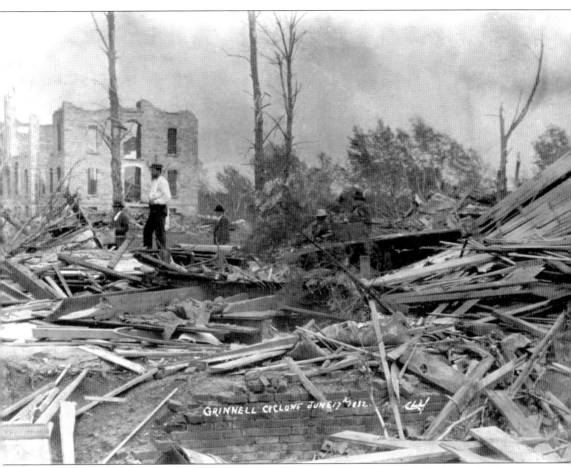

An 1882 tornado destroyed much of the north side of Grinnell, including the entire Iowa College campus. Forty people—including two college students—were killed by the massive twister. Striking just after 8:00 p.m. on June 17, ten days before commencement, the campus death toll could have been much worse. The three-story West College building was demolished (remnants are pictured in this postcard), yet only one student inside it died. The other student died trying to flee the newer Central College building, which was also destroyed. (Grinnell College Archives.)

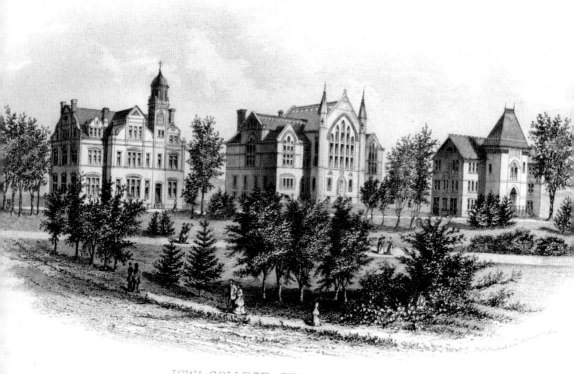

IOWA COLLEGE_GRINNELL.IOWA.

After the cyclone, J.B. Grinnell helped raised the money to begin rebuilding the college. Four buildings were planned—Alumni, Blair, Chicago, and Goodnow Halls—creating a southern border along Sixth Avenue. This rendering features Alumni, Blair, and Chicago—not one of which stands today. A fourth building, Goodnow, still anchors the college's Park Street block. (Grinnell College Archives.)

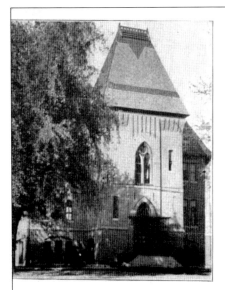

In accordance with your request, kindly send to me, without any expense to my-self, Iowa College litera-ture as it is issued from the press.

Name _____

Town _____

State _____

Alumni Hall, Iowa College

'0 B

This is a request for information aimed at prospective students in 1908, the year before Iowa College would be renamed Grinnell College. Alumni Hall, the first building to arise from the rubble of the cyclone, is pictured. (Grinnell College Archives.)

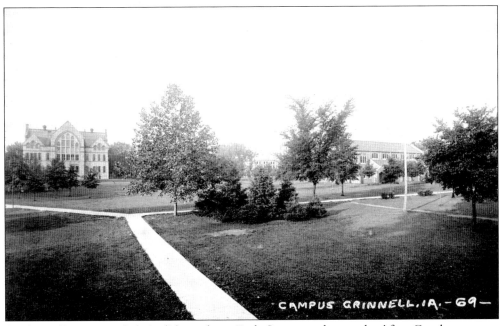

As the college expanded, it did so along Park Street to the north. After Goodnow came Carnegie, Herrick, and Steiner. This view from the northeast shows Blair and part of Herrick. (Ivan Sheets Collection.)

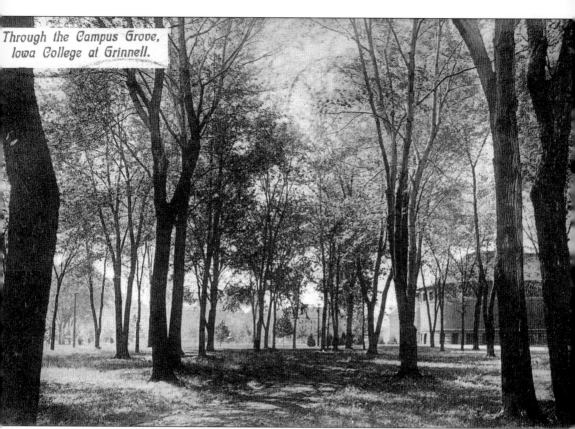

Through the Campus Grove, Iowa College at Grinnell.

The college campus was dominated by trees in 1908—a far cry from the "treeless prairie" J.B. Grinnell had discovered 54 years earlier. The Men's Gymnasium can be seen "Through the Grove of Trees." This was also a time when the students enjoyed more access to cultural and recreational activities. Music, drama, and intercollegiate athletics had taken a more prominent role on campus. (Grinnell College Archives.)

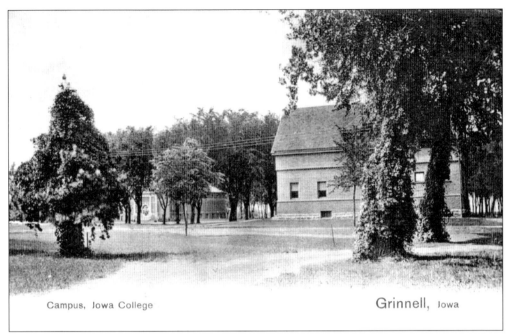

Campus, Iowa College

Grinnell, Iowa

Another view of central campus *c.* 1908, though in this instance both the Men's and the Women's (Rand) Gyms are visible. The presence of two gymnasia underscores the role of athletics on campus at that time. (Ivan Sheets Collection.)

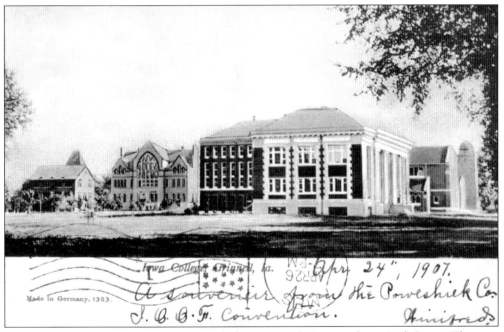

This 1907 view of the campus looks south from Seventh Avenue down Park Street. The core of buildings has increased dramatically since the cyclone, adding the Carnegie Library (foreground), the YMCA Building (now Steiner), Mears Cottage, and the two gymnasia. There would be a construction boom in the decade to follow. (Mike Hotchkin Collection.)

Iowa College Campus from the Northwest

Another view down Park Street of the central campus, this image was taken in the winter. The Carnegie Library dominates the view from Seventh Avenue, with Alumni Hall visible in the background. (Stewart Library Collection.)

Iowa College Campus in Winter

A Merry Christmas & Happy Newyear
myron.

A winter card bearing holiday greetings (*c.* 1907) features a view of campus from the northeast. Herrick Chapel is on the immediate right, with the Christian Association Building (Steiner) barely visible to the left of Herrick. Goodnow is at the center of the pictures, and Chicago appears on the left. (Mickey Munley Collection.)

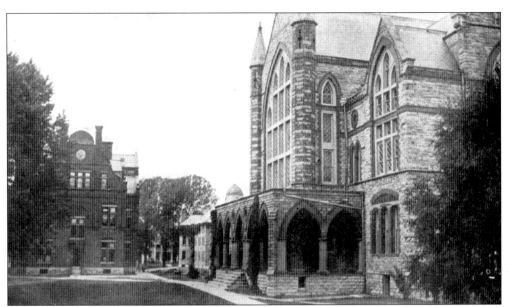

Two of the four pillars of the post-cyclone campus reconstruction were Blair and Chicago Halls. Goodnow, the only one of the four still standing, is just visible in the background behind Blair. Alumni Hall is not visible. Blair is the prominent building on the right; Chicago is the building on the left. Initially, the three bore the names of the original campus buildings. Alumni Hall was called East College, Blair was Central, and Chicago was West. Their names were changed after two years to recognize donors. (Stewart Library Collection.)

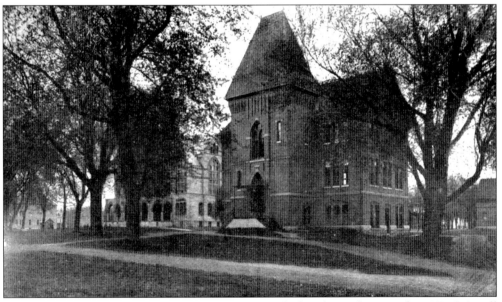

Alumni Hall was the first building to be constructed after the cyclone. In fact, J.B. Grinnell himself broke ground for the building just weeks after the disaster. With the dust of destruction still in the air, Grinnell proclaimed the college would come back even better than before. Later called the Music Building, Alumni Hall was razed in 1958 to make way for Burling Library. (Grinnell College Archives.)

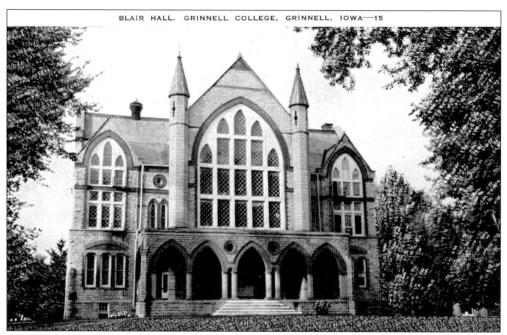

There is no building on the Grinnell College campus, past or present, which could match Blair Hall's sheer magnificence. Built during a four-year period (1882–1886), Blair was a massive Gothic structure with cathedral-style windows. Named for the founder of the Lackawanna Coal and Iron Company, John I. Blair (a close friend of J.B. Grinnell), Blair Hall housed the departments of chemistry, physics, natural science, and the college chapel (prior to Herrick Chapel). It also included a large museum that was a significant tourist attraction. (Ivan Sheets Collection.)

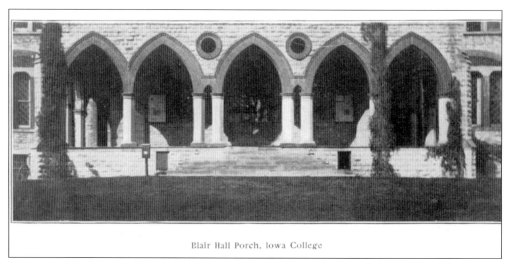

Blair Hall Porch, Iowa College

The Blair Hall porch was a campus focal point for years. It was the site of many celebrations, presentations, and concerts. Class pictures were taken on its steps. Blair, which had fallen into disrepair, was razed in 1962 to create space between the new library and the new fine arts building. (Stewart Library Collection.)

84

Chicago Hall drew its name from the many Chicagoland donors, including the Chicago Board of Trade, who responded to J.B. Grinnell's pleas for help after the cyclone. A three-story brick building, it featured the bell that had been pulled from the ruins of Central College. Later known as Magoun Hall (for the college's first president), Chicago first housed classrooms and the music department. It then became primarily the college's administration building. It was razed in 1959 to make room for the new Fine Arts building. (Marian Dunham Collection.)

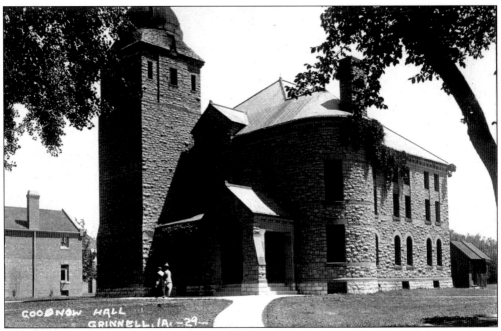

Goodnow Hall is all that remains of the original four buildings of the 1882–1886 post-cyclone era. Dedicated in 1885, the building is named for E.A. Goodnow, who donated the money for its construction. He also gave $5,000 for Mears Cottage and provided scholarships for female students. (Ivan Sheets Collection.)

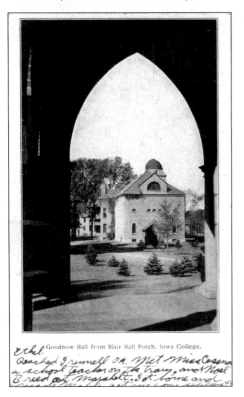

Goodnow Hall (as seen from the Blair Hall porch) was designed by Stephen Earle, a protégé of Henry Hobson Richardson, the architect who developed the style known as Richardsonian Romanesque. Its Sioux Falls quartzite exterior gives Goodnow its reddish tint. The building served as an observatory, as well as the college library, until Carnegie was built in 1905. It has housed faculty offices and classrooms ever since, and is now home to the Anthropology Department. (Ivan Sheets Collection.)

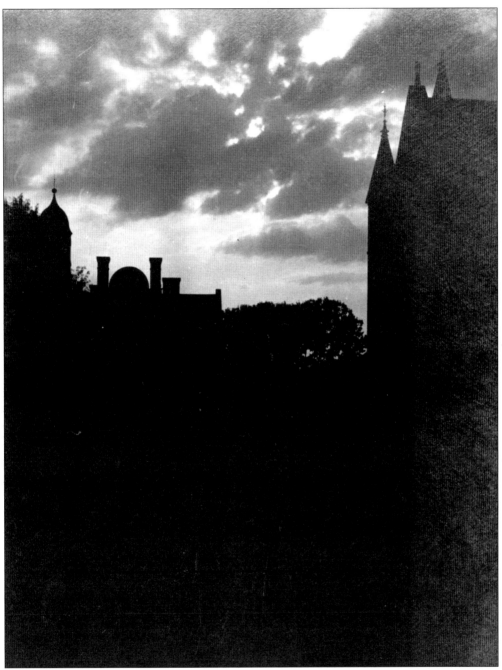

This unique postcard, "Bell Tower and the Spires in Silhouette" features Blair (the spires), Chicago (the bell tower), and Goodnow. These buildings were beloved at that time, and the demise of Blair and Chicago continues to trouble preservationists. However, the college's decision to restore Goodnow in the 1990s was a victory. The building had been allowed to deteriorate, as was the case with Blair, Chicago, and Alumni. In fact, at one time Goodnow was closed because state officials ruled it was unsafe. But trustees agreed to restore it to its original elegance, and it was re-dedicated in 1995. (Grinnell College Archives.)

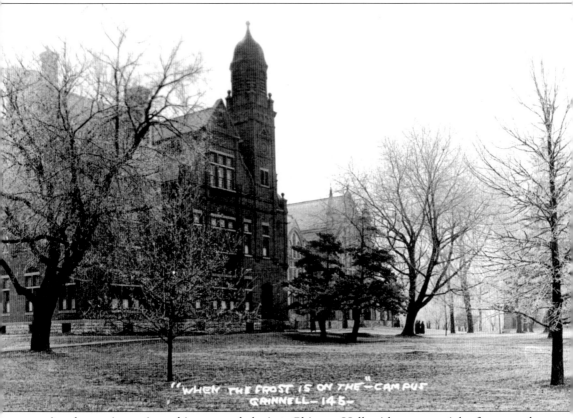

"WHEN THE FROST IS ON THE" CAMPUS
GRINNELL—145—

Another unique view, this postcard depicts Chicago Hall with an overnight frost on the nearby trees. Chicago was renamed Magoun Hall to honor the college's first president, George Frederic Magoun. Magoun was named president in 1865 and served until 1884. He joined J.B. Grinnell as a primary fundraiser for the college. A New England native and a Bowdoin graduate, Magoun found it difficult convincing wealthy easterners to contribute to a "Western" college. (Grinnell College Archives.)

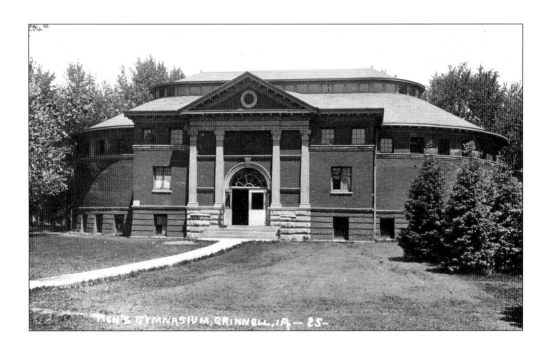

The college's second president, George Gates, was a strong supporter of intercollegiate athletics. In fact, Iowa College was a football powerhouse in the 1890s, with wins over Iowa, Minnesota, and Nebraska. The Men's Gymnasium and the separate but equal Women's (Rand) Gym were turn-of-the-century acknowledgements of the importance of athletics. Rand was destroyed by a fire in 1939. The Men's Gym was renamed the Women's Gymnasium after Darby Gym was built in 1942. It was razed in 1972. (Top: Stewart Library Collection. Bottom: Ivan Sheets Collection.)

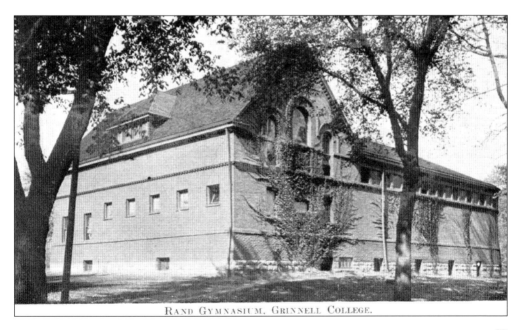

RAND GYMNASIUM, GRINNELL COLLEGE.

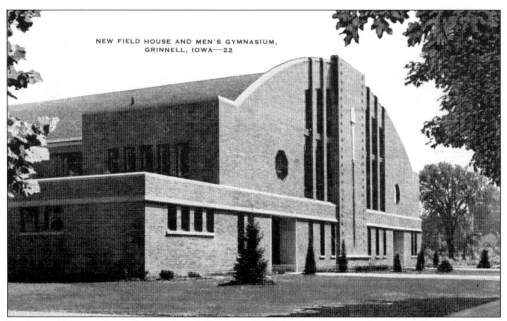

NEW FIELD HOUSE AND MEN'S GYMNASIUM, GRINNELL, IOWA—22

Built in 1942 as the college housed first the Officer Candidate School and then the Army Specialized Training Program, Darby Gymnasium replaced the old men's gymnasium, which was the only gym on campus after a fire destroyed the women's gymnasium (Rand) a few years earlier. Darby was the only Art Deco building on campus, and its unique roof was supported by a Phillippine Truss System. It was scheduled to be razed in 2004. (Ivan Sheets Collection.)

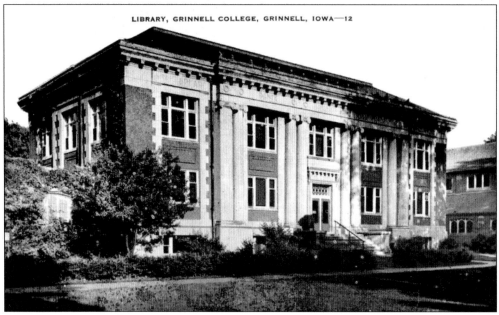

LIBRARY, GRINNELL COLLEGE, GRINNELL, IOWA—12

As library use in Goodnow Hall grew just after the turn of the century, the college recognized that it needed more academic space. Industrialist Andrew Carnegie donated $50,000 for a new library, and Carnegie Library was built in 1905. It became the college's second building on Park Street, located north of Goodnow. (Ivan Sheets Collection.)

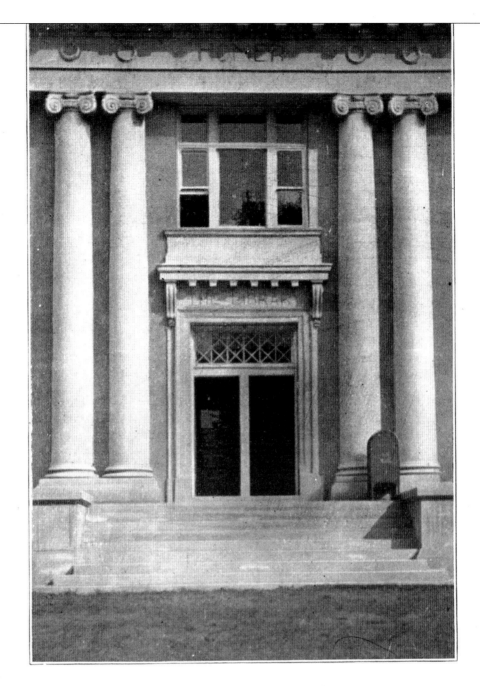

Entrance to Carnegie Library

Carnegie, which was converted into academic space in 1959, is a modified Classical structure. It features six columns and a frieze with the names of Shakespeare, Dante, Homer, Plato, Michelangelo, Darwin, Goethe, Galileo, Emerson, and Caesar. (Ivan Sheets Collection.)

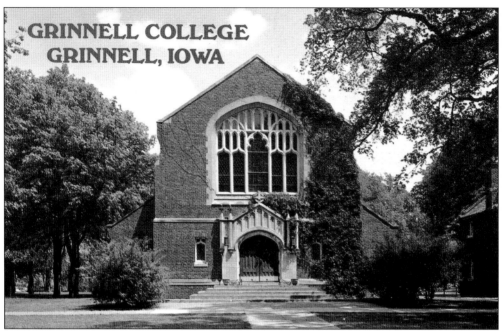

GRINNELL COLLEGE
GRINNELL, IOWA

Named for the early Grinnell pioneer, minister, and one-time college trustee Stephen L. Herrick, Herrick Chapel pays homage to the school's Congregationalist past. Built in 1906, Herrick is an example of Perpendicular Gothic design and features stained glass renderings of Holman Hunt's painting, "The Light of the World," and Heinrich Hoffman's "The Ascension." (Ivan Sheets Collection.)

This view of the Herrick Chapel doorway looks west on Seventh Avenue. The chapel houses two relics of the college's past. In the vestibule is a bronze plaque that recognizes the "Iowa Band"—the 11 Congregational ministers who founded Iowa College in Davenport in 1846. In the northwest corner of the sanctuary is a marble plaque which bears the names of 11 Iowa College students who died in the Civil War. (Ivan Sheets Collection.)

Christian Associations Building, Iowa College

Iowa College of the early 1900s was developing a reputation for nurturing young public servants. For that reason, it was logical for the college to build a Christian Associations Building, since the YMCA and YWCA were quite active at the time. The name of the building was changed to Steiner in 1959 to recognize Edward Steiner, a legendary professor of Applied Christianity and mentor of Harry Hopkins, who was closely linked to the Social Gospel movement. With the completion of the Christian Associations Building, the construction boom of 1904–1907 was complete. The college now had a library, a chapel, and a focal point for its Christian-based public service component. (Ivan Sheets Collection.)

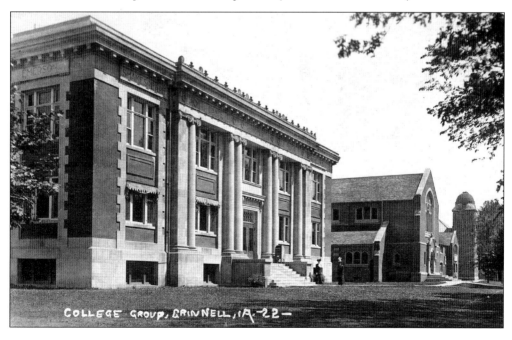

COLLEGE GROUP, GRINNELL, IA-22-

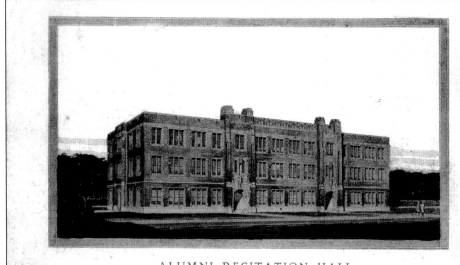

ALUMNI RECITATION HALL
(Ready in fall, 1916)
For admission to Grinnell College, or for information, address
THE REGISTRAR, Grinnell, Iowa

Under President John H.T. Main, the campus rapidly expanded during the first two decades of the 20th century. Main's commitment to a residential college resulted in new dorms, but there was still a growing need for more (and more modern) academic space. Main accomplished that with the construction of Alumni Recitation Hall, better known as ARH, in 1916. The college quickly made use of it as it sought prospective students. (Mickey Munley Collection.)

GRINNELL COLLEGE calls your attention to the growing demand for men and women trained in colleges of the better type, and invites your investigation.

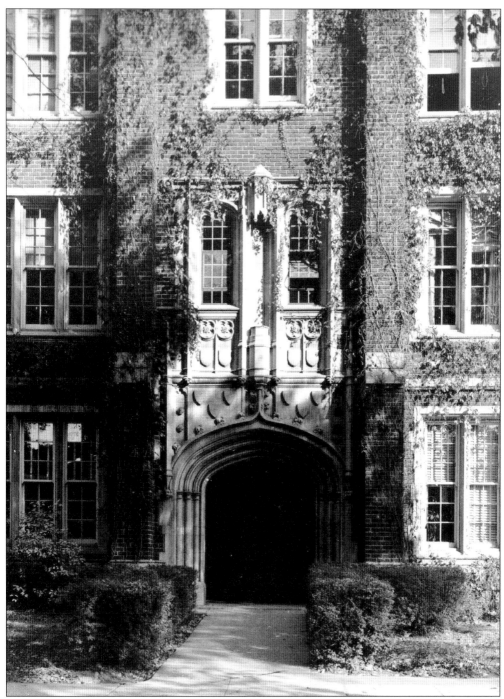

Though it was the first of the college's "modern" academic buildings, ARH had the appearance of a medieval fortress. The Gothic features in this Tudor structure were incorporated, in part, to allow for a lecture hall on the ground floor while accommodating an auditorium on the upper two floors. Even today, ARH has a 158-seat auditorium on its third floor. (Mickey Munley Collection.)

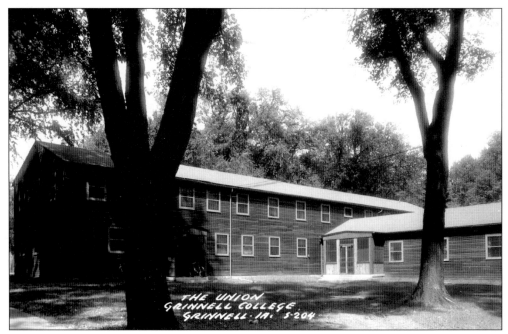

The predecessor of the Forum and the planned Rosenfield Campus Center, the Union was the student union, a social gathering spot. Located on the site of the current Forum, it originally served as barracks for officer candidates during World War II. (Mickey Munley Collection.)

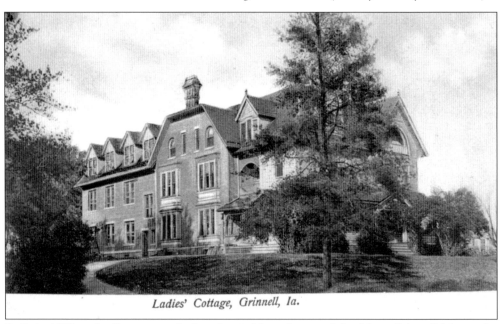

Ladies' Cottage, Grinnell, Ia.

Built in 1888 as the first women's dormitory, Mears is named for Mary Grinnell Mears, the daughter of J.B. Grinnell. E.A. Goodnow donated $5,000 for construction of the building, which extended the campus to the east. Mears initially housed 28 women, but a 1904 expansion allowed 100 women to live there. It was renovated in the 1980s and now houses the departments of History and English. (Ivan Sheets Collection.)

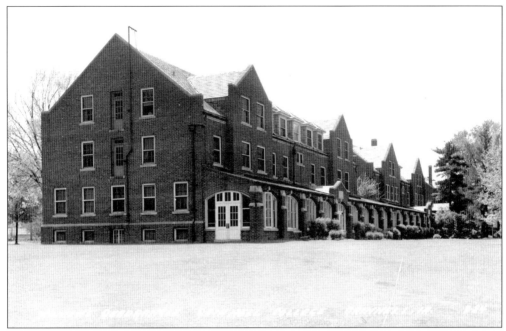

The first of the new dormitory projects of President John H.T. Main was the Women's Quadrangle, built in 1915. These dorms, which preceded the men's dorms by a year, are now known as South Campus. They greatly enhanced the on-campus living options for women, who previously had only the option of Mears Cottage. (Ivan Sheets Collection.)

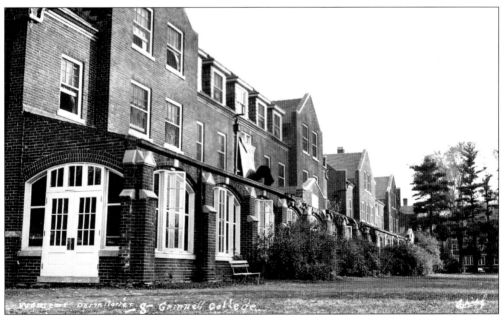

The college spent an estimated $1 million for the men's and women's dormitories between 1915 and 1917. The women's dorms were made up of five individual buildings: Cleveland, James, Haines, Read, and Loose. (Mickey Munley Collection.)

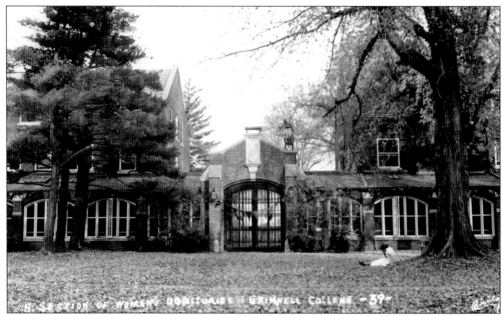

This gateway between Haines Hall and James Cottage was one of two highly-recognizable entrances on campus (the other being the Gates-Rawson Tower on North Campus). (Grinnell College Archives.)

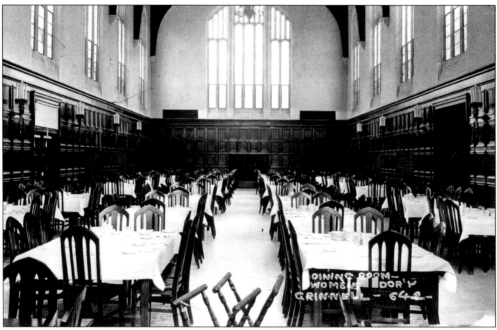

At the heart of the Women's Quadrangle was Main Hall, named for President John H.T. Main. Main is considered largely responsible for transforming the small Iowa College into the nationally-recognized Grinnell College. He served as president from 1906 until his death in 1931. (Ivan Sheets Collection.)

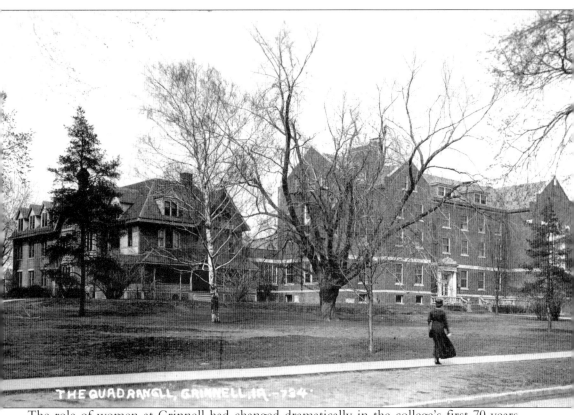

THE QUADRANGLL, GRINNELL, IA - 734

The role of women at Grinnell had changed dramatically in the college's first 70 years. Initially viewed as secondary scholars (who received diplomas rather than degrees), the number of women attending the school continued to grow. The five women's dormitories acknowledged that growth and the role women would play in the school's future. (Grinnell College Archives.)

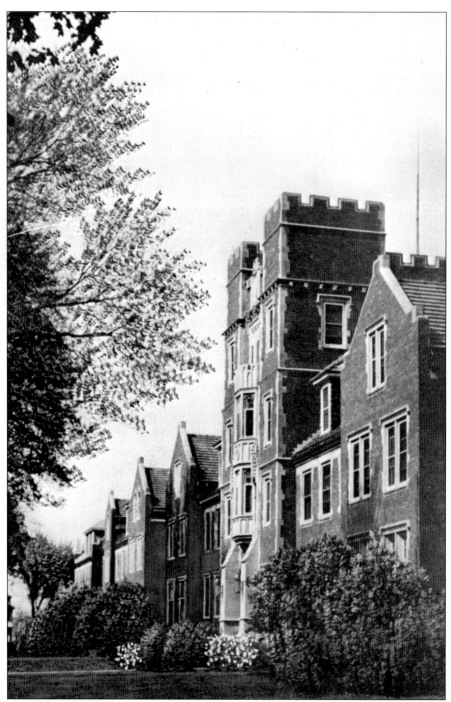

Built in 1916 and 1917, the six buildings that made up the men's dormitories (now North Campus) were an attempt to create a more residential atmosphere at Grinnell. Students, especially men, had lived in off-campus housing prior to that time. The creation of separate men's and women's dorms on opposite ends of campus had other objectives. The dorms opened in 1917, just as male students were enlisting to fight in World War I. (Ivan Sheets Collection.)

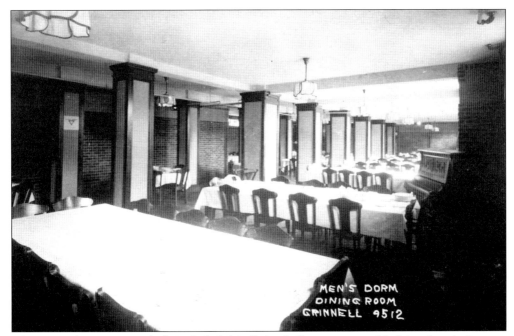

The men's dormitories, which included this dining hall, were to provide "simple, wholesome, and economical" life for its residents. For men who had been living on their own, the change created some challenges and some opportunities. Having someone else cook for them was considered an opportunity. (Ivan Sheets Collection.)

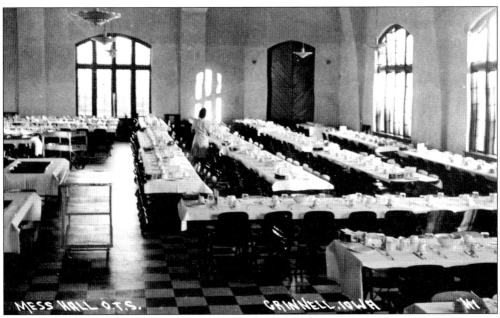

With the arrival of the Officer Candidate School during World War II, the college was forced to quickly create new facilities. In 1942, it built a mess hall, which became Cowles, and Darby Gymnasium. Almost 2,000 officer candidates and other military trainees came through Grinnell between 1942 and 1944. (Mickey Munley Collection.)

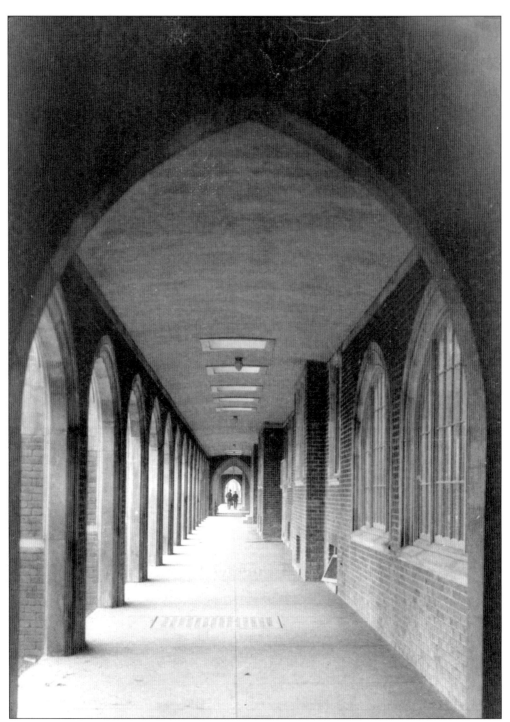

Another goal of the college in its creation of men's and women's dormitories was the fostering of community. The inclusion of cloisters (loggia) bridged the separate buildings within the dorm clusters together. The men's cloister featured 38 arches as it spanned the east side of the buildings. (Stewart Library Collection.)

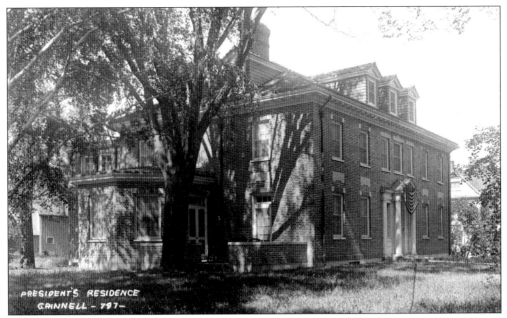

College presidents lived at this site on the northwest corner of Fifth Avenue and Park Street from 1887 to 1961, starting with George Augustus Gates and ending with Howard Bowen. The original building was razed in 1917, and the new residence opened later that year. In 1961, a new house was built six blocks to the north for President Bowen. The old residence, now known as Grinnell House, became the college's primary guest house. (Grinnell College Archives.)

Many of the most picturesque photos of campus—including this postcard, "The First Snow" featured Chicago Hall. Chicago, however, was no match aesthetically for Blair Hall. Perhaps its more understated features, rather than the Gothic aura of Blair, were viewed as more compatible for images like "The First Snow" or "When the Frost is on . . . the Campus." (Grinnell College Archives.)

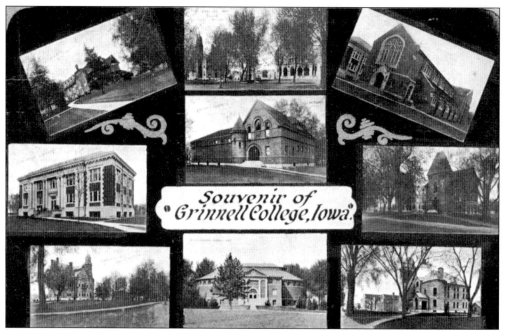

This is a standard commercial postcard from *c.* 1909, the year Iowa College evolved into Grinnell College. Pictured are the campus landmarks at that time, including recent additions Herrick Chapel and Carnegie Library. Also pictured is the men's gym, the home of the 1909 state champion basketball team. (Stewart Library Collection.)

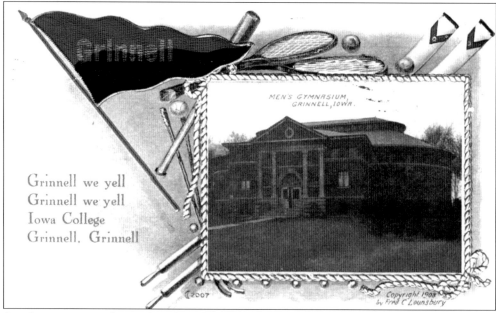

Another commercially-produced card, this "Yell for Grinnell" includes references to both Iowa College and Grinnell. Trustees in 1909 voted to change the name of the school from Iowa College to Grinnell College to honor J.B. Grinnell. The change came on the 50th anniversary of the college's move from Davenport to Grinnell. (Mickey Munley Collection.)

Grinnell Track Team

Beginning in the 1890s, Iowa College developed a regional reputation as an athletic powerhouse. Its strength continued into the first decade of the 1900s, including a state track championship in 1907. These cards celebrate the team and its state title. The image of the *Des Moines Capital* front page shows that the IC team defeated Drake, "Ames," Iowa, Morningside, and Simpson. (Mickey Munley Collection.)

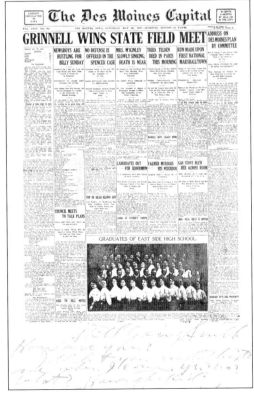

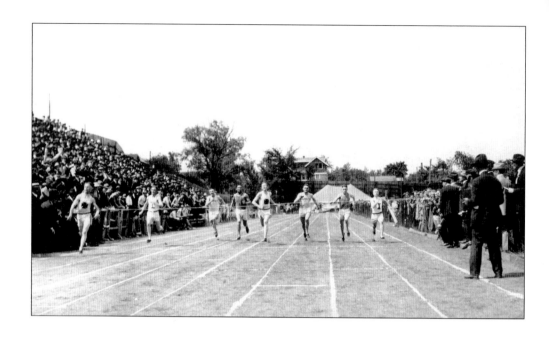

The 1907 state track title was clearly a source of great pride for the college. The number of postcards dedicated to the championship—and to the track team as a whole—is significant. These images show a track meet in action (from the Grinnell College Archives) and meet officials and fans awaiting action. (Mickey Munley Collection.)

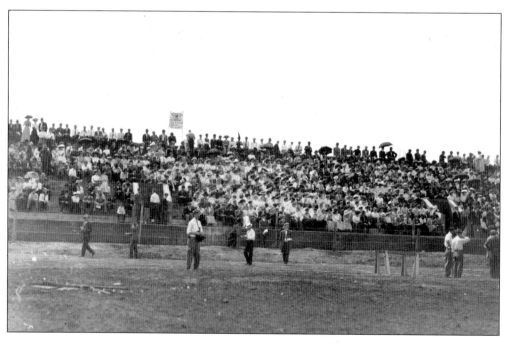

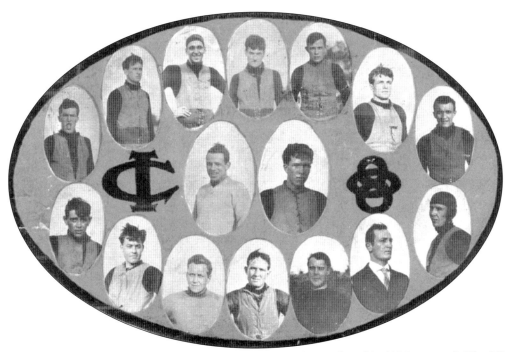

Not to be outdone, the Iowa College football team is featured in this 1908 postcard. The IC gridders had seen great success in the 1890s, defeating much larger state universities. Their fortunes then flagged for a few years, but the 1908 team was rebuilding. Within a few years, they would again defeat the University of Iowa. (Mickey Munley Collection.)

While athletics were getting the attention of some, students had an array of activities from which they could choose. The men's glee club was one option, as were various theatre, literary, and cultural groups. That fit in with President John H.T. Main's vision of an education that was broader than simply academic learning. (Grinnell College Archives.)

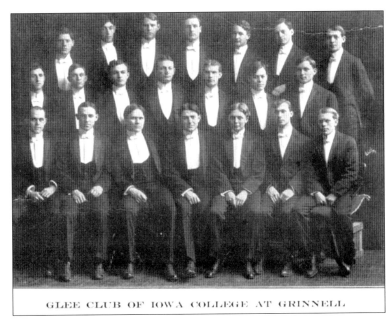

GLEE CLUB OF IOWA COLLEGE AT GRINNELL

This postcard, simply titled "Grinnell Campus," underscores the warmth that students felt for the college. There are many examples of artistic cards that show the school in an attractive, positive light. And that was an image that students wanted to share with others. Those warm feelings continue today among both students and alums. (Grinnell College Archives.)

Eight

PEOPLE, PLACES, AND EVENTS

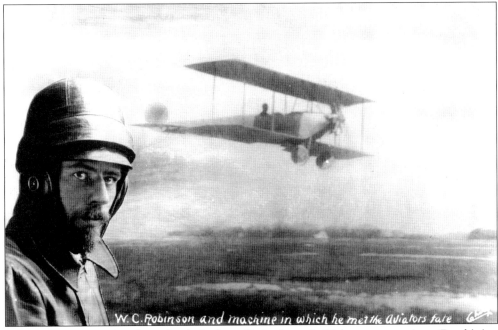

W. C. Robinson and machine in which he met the aviators fate

Billy Robinson, a Grinnell mechanic, had an affinity for early 20th century engines. Combining that expertise with a fascination with flight, in 1911 he developed a six-cylinder, 100-horsepower radial airplane engine, a concept that took the aviation industry in a new direction. He named the plane on which he tested the engine "Scout." (Stewart Library Collection.)

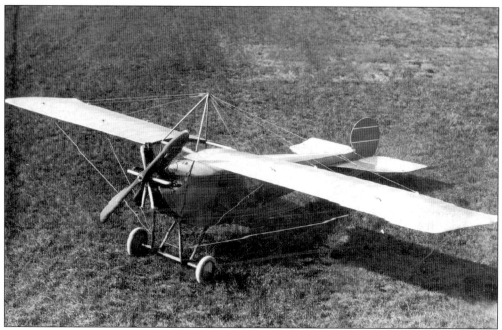

Robinson was an aviation pioneer, but he didn't get a pilot's license until 1912. In 1913 he founded the Grinnell Aeroplane Company, which would build his new plane and engine. In 1914 he set a speed and distance record carrying mail from Des Moines to Kentland, Indiana. (Stewart Library Collection.)

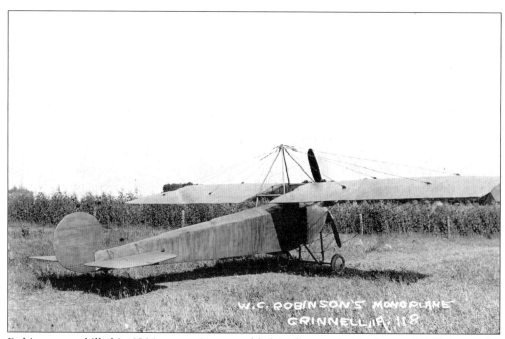

Robinson was killed in 1916 attempting a world altitude record, which was 17,000 feet at the time. He had felt at the time that a spectacular feat could revive the flagging fortunes of his Grinnell Aeroplane Company. (Stewart Library Collection.)

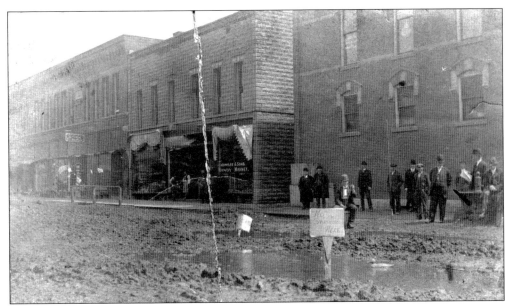

A take-off of a similar, better-known photograph of Ed Brande (the son of the Baptist minister Thomas Brande) pretending to be duck hunting on Main Street. In this instance, a man (Brande?) is fishing in a mudhole on Main Street. The sign near the hole warns "No Swimming." (Stewart Library Collection.)

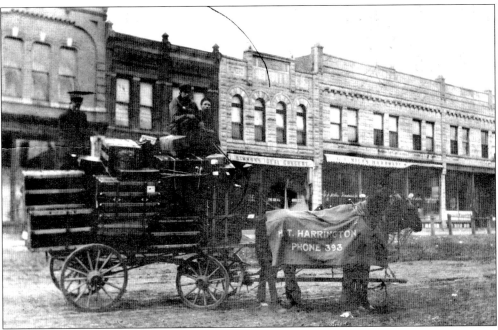

This image shows driver and his wagon on the 900 block of Broad Street. It appears the wagon is loaded with luggage, and the fact that he is headed north might indicate the driver (H.T. Harrington) is bringing a college student to campus from the depot. The businesses in the background include Simmon's Ideal Grocery and G.L. Miles Hardware. (Stewart Library Collection.)

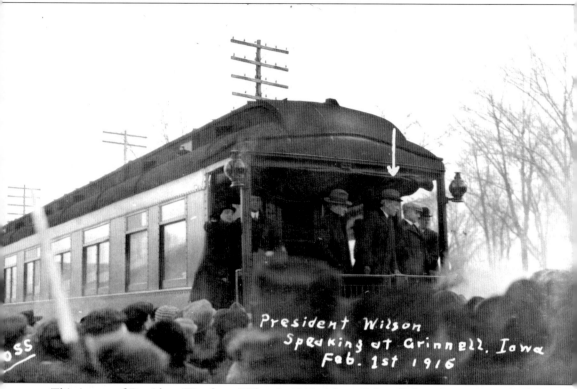

President Wilson
Speaking at Grinnell. Iowa
Feb. 1st 1916

This image of President Woodrow Wilson's 1916 visit to Grinnell doesn't represent the last time those tracks carried a sitting president. Herbert Hoover also visited during his 1932 campaign. Harry Truman came through Grinnell during his famous 1948 whistlestop tour, speaking to a crowd of hundreds on his way to deliver a major address on agriculture in Dexter, Iowa. (Mickey Munley Collection.)

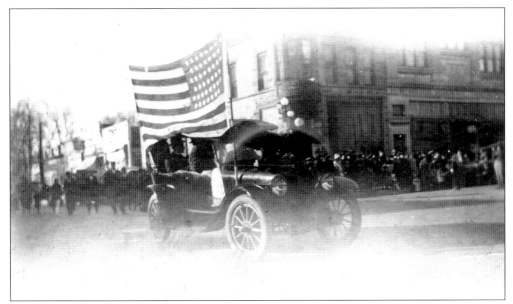

This image reveals a turn-of-the-century downtown parade featuring a car with an oversized American flag. The car is headed east on Fourth Avenue at Main. Though the image is somewhat faded, this could be a parade of Spanish-American War Veterans, possibly from Grinnell's "Company K." (Stewart Library Collection.)

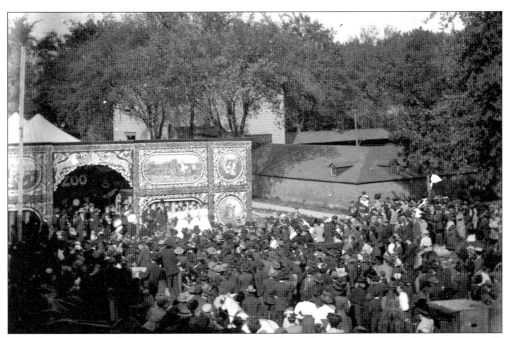

The circus came to Grinnell and set up on Broad Street just south of Fifth Avenue. There is a band standing in the doorway to the "Circus Zoo" structure, and what appear to be performers to the right of the doorway. The J.W. Norris livery barn is the building to the right. (Stewart Library Collection.)

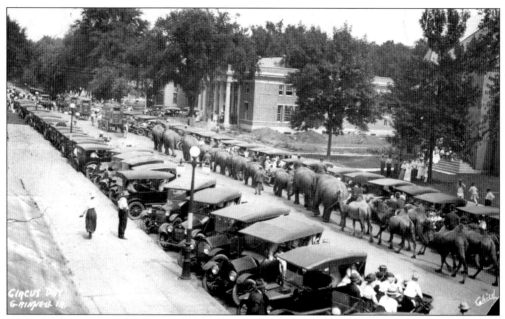

This circus parade up Broad Street passes the site of that earlier circus. In this instance, a line of elephants (with trunks holding the tails of the animal ahead) and camels trail several horse-drawn circus wagons. The year must be 1916 or 1917, since construction of the post office is just being completed. (Stewart Library Collection.)

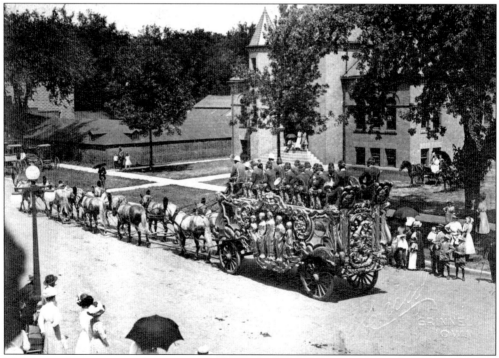

This image depicts yet another circus parade, passing the library, however with no post office in sight. Riding in the horse-drawn circus wagon are members of a circus band. (Stewart Library.)

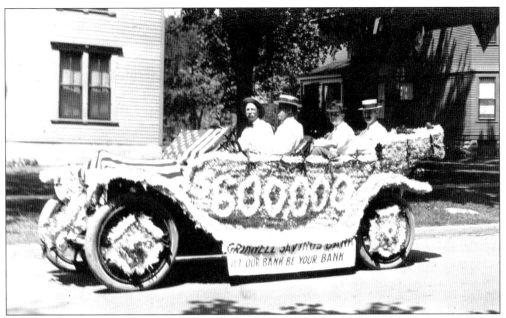

This is the 1913 Fourth of July float for Grinnell Savings Bank, celebrating its $600,000 in assets. The houses in the background suggest that this is the 1200 block of Broad Street. (Ivan Sheets Collection.)

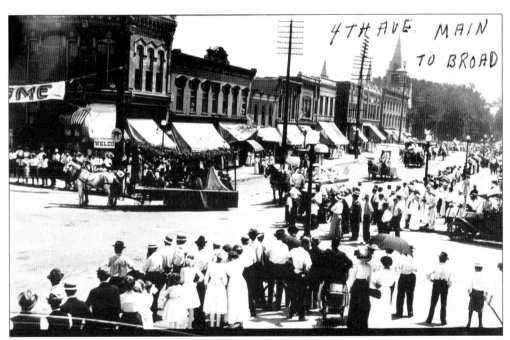

A parade moves west along Fourth Avenue and turns north on Main. Signs along the parade route indicate the parade is a "welcome" for something or someone. (Stewart Library Collection.)

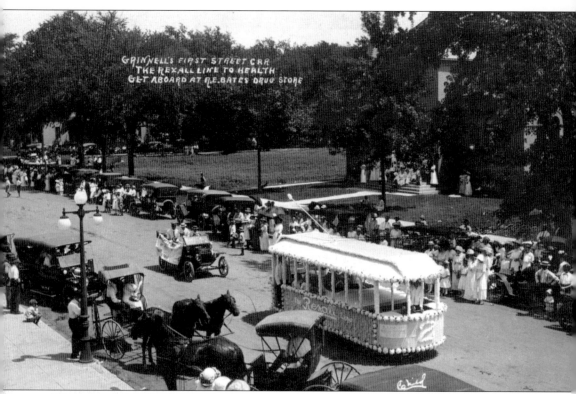

This postcard commemorates the "Rexall Streetcar"—in reality a parade float moving south on Broad Street. The date of this picture must be between 1910, when Roy Bates affiliated his drugstore with Rexall, and 1916, when the post office was built. The vehicle behind the streetcar is promoting Grinnell Motors, which the banner says sells the "Spaulding." (Stewart Library Collection.)

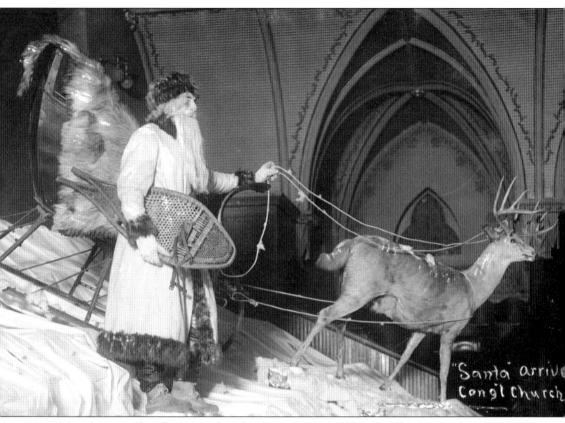

It's 1911 and Santa Claus has arrived at the Congregational Church. This image should quiet anyone who insists the commercialization of Christmas is a recent phenomenon. But it does afford one of the few postcard views inside the Old Stone Church. (Stewart Library Collection.)

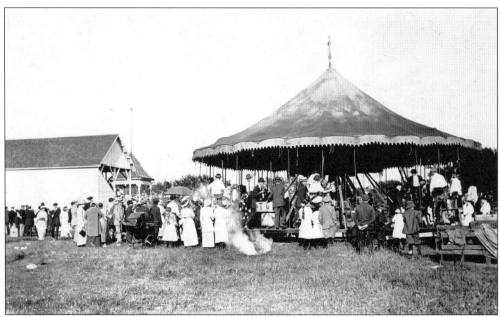

This real photograph postcard bears only the words "Grinnell Fair," but the presence of a carousel and what looks to be a grandstand might indicate it's the county fair. (Stewart Library Collection.)

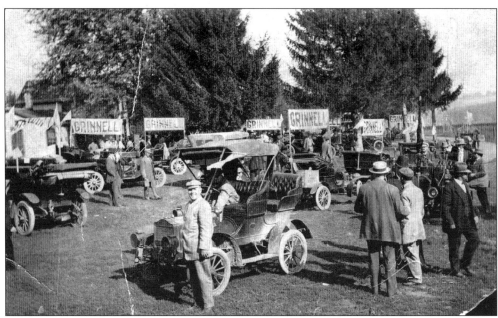

There is no available information about this postcard, but it is clearly an impressive gathering of early automobile enthusiasts. Likely, the presence of Spaulding gave Grinnell some additional standing in auto circles. It could also be a day trip of auto enthusiasts who frequently used the River-to-River Road to show off their vehicles. (Stewart Library Collection.)

PENQUITE CABIN VILLAGE - U. S. NO. 6, GRINNELL, IOW

The advent of the automobile and the construction of the River to River Road (Highway 6) brought a number of new visitors to Grinnell. As was the case with other early highways, businesses quickly emerged to handle these new auto travelers. Penquite Village was located on Highway 6 on the eastern edge of Grinnell, offering gas, food, and lodging. Shortly after passing this point, motorists would dip south to Fourth Avenue and roll through downtown Grinnell before turning back north to Sixth. (Stewart Library Collection.)

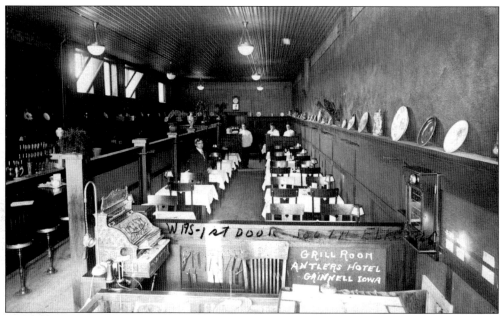

The Antlers Hotel anchored the block of Main Street between Fourth and Commercial. Located just south of the Elks Building/Rexall Drug, the Antlers also featured a grill that was a popular dining spot. This view shows the inside of the grill. (Stewart Library Collection.)

It's difficult to determine the location where this photo of three well-dressed men was taken. But it looks like they're headed to a show, with the promotional panel in the left corner reading "September Morn," the name of a Broadway play from that era. (Stewart Library Collection.)

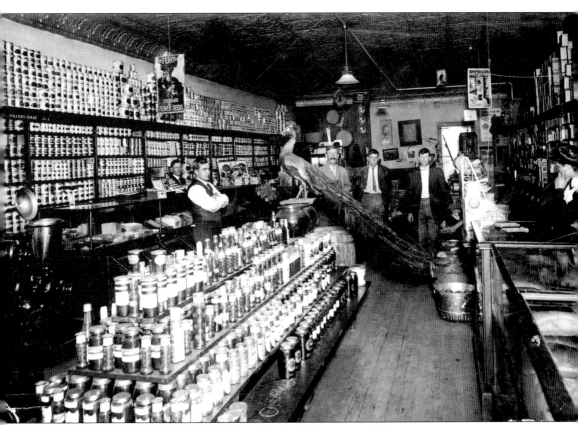

A description for this image reads: "Inside a store with owner John Atherton." It could be the Prescription Pharmacy at 909 Main Street, based on a 1905 photograph of that business. Note some of the interesting items displayed in the store. (Stewart Library Collection.)

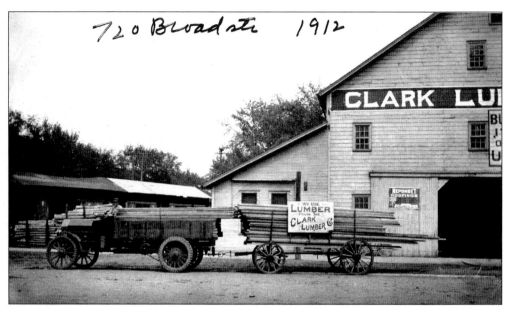

Located on Broad Street just south of downtown, Clark Lumber was in business for years. Notice the advertising on the wagon full of lumber. The lumberyard would have been located across the street from the Glove Factory. (Stewart Library Collection.)

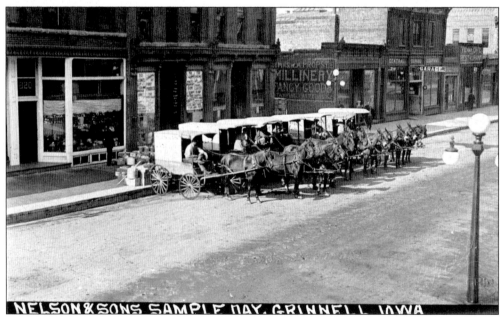

An example of a promotional photo from Nelson and Sons "Sample Day," with the delivery wagons lined up on Fourth Avenue. To the right of the wagons are the buildings that were razed to make way for Grinnell Savings Bank and the Elks Building. (Ivan Sheets Collection.)

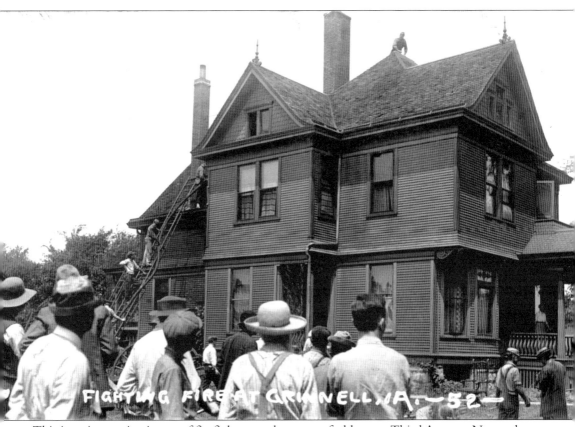

This is an interesting image of firefighters at the scene of a blaze on Third Avenue. No smoke or flames can be seen, yet several volunteer firefighters are on the ladder to the left. Another firefighter is on the roof near the top of the image. A woman is standing at the front door, not looking too concerned. The four-square style was extremely popular, with hundreds of similar houses still standing throughout Grinnell. (Stewart Library Collection.)

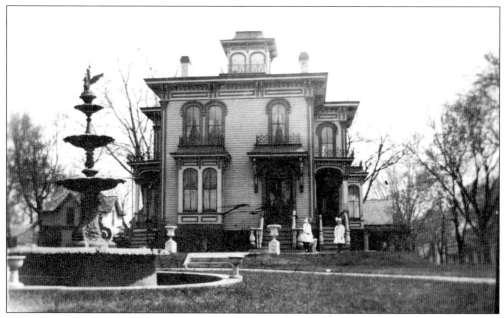

This very attractive Italianate-style home with a spacious lawn is J.B. Grinnell's, looking south. The fountain sits where the Monroe Hotel was later built. At this time, Grinnell was considered one of the wealthiest communities in Iowa. Many homes had lush lawns with expansive gardens and orchards. These Italianate houses are still plentiful throughout the community. (Stewart Library Collection.)

This is a real photograph postcard that simply reads on the reverse side, "Our House on East Street." This house, 919 East Street, sits just south of the Baptist Church between Fourth and Fifth Avenues. It is essentially unchanged from the time this photo was taken. (Stewart Library Collection.)

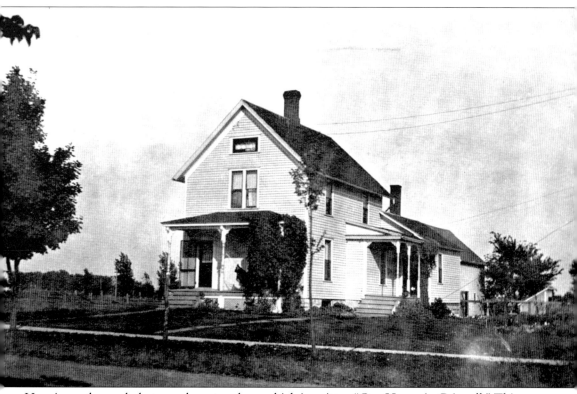

Here is another real photograph postcard, on which is written "Our House in Grinnell." This home is more difficult to pinpoint, but it was clearly on the outskirts of town at the time the photograph was taken. (Stewart Library Collection.)

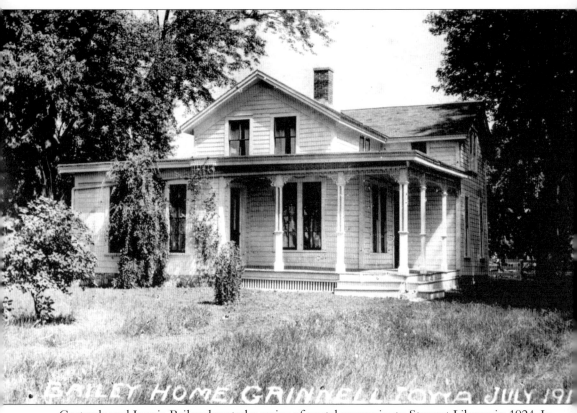

Gertrude and Jennie Bailey donated a series of postal souvenirs to Stewart Library in 1924. In that collection were numerous vintage postcards, including several real photograph postcards of the Bailey family home. This photo was dated 1915. (Stewart Library Collection.)

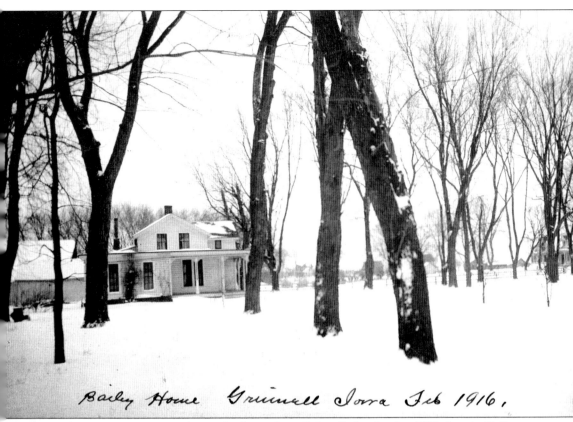

Bailey House Grinnell Iowa Feb 1916.

The Bailey sisters were members of a long-time Grinnell family. In 1933, Jennie Bailey donated land on the northwest side of town that would be used for Bailey Park, and ultimately for Bailey Park School in 1957. This image of the Bailey family home is dated 1916. (Stewart Library Collection.)

ABOUT 1910

This is a fashionable, and rather independent, woman (for the time) somewhere in Grinnell just after the turn of the century. (Stewart Library Collection.)